IMAGES
of America

OXON HILL

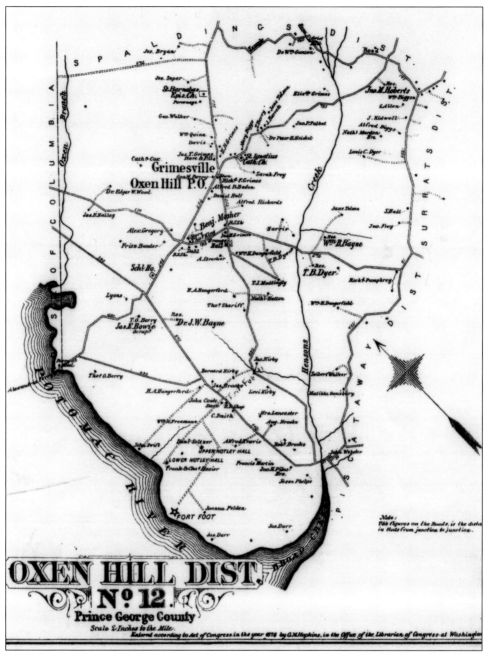

This 1867 historic map of Prince George's County shows the original Oxon Hill District, highlighting the property of major land-owners such as Dr. J. W. Bayne, Thomas Sheriff, T. O. Berry, T. J. Mattingly, T. B. Dyer, William Bayne, and Jason Grimes, as well as the Grimesville Post Office. (Courtesy of the Prince George's County Historical Society.)

ON THE COVER: St. Paul United Methodist Church choir poses for an official church photograph. St. Paul is the oldest known African American church in Prince George's County. It was founded in 1791, after it split from Oxon Hill United Methodist Church. (Courtesy of the St. Paul United Methodist Church History and Records Ministry.)

IMAGES
of America

OXON HILL

Nathania A. Branch Miles
and Jane Taylor Thomas

ARCADIA
PUBLISHING

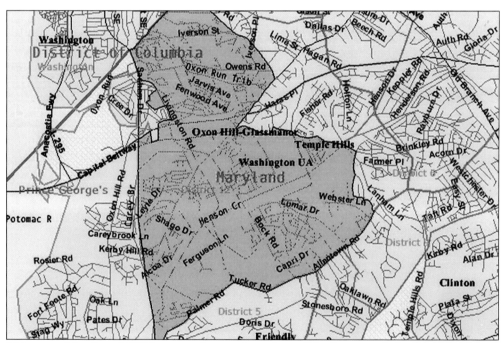

This map of the Oxon Hill District outlines its boundaries. The district includes the communities of Temple Hills, Glassmanor, and Forest Heights, to name a few. The Oxon Hill community borders the District of Columbia, and I-495 extends into Alexandria, Virginia. (Courtesy of the Library of Congress, Prints and Photographs Division.)

CONTENTS

ACKNOWLEDGMENTS

The authors would like to acknowledge and express thanks to the many people who contributed valuable history and pictures to the Images of America: *Oxon Hill*. Many thanks are given to historian Frank Faragasso of the National Park Service Eastern District; Oxon Hill Farm park rangers Marilyn Brown and Vanessa Molineaux; Betty Carlson Jameson and Steven Abramowitz, from Maryland–National Capital Park and Planning Commission; Susan Pearl and staff from the Prince George's County Historical Society; Allan O. Hare and Michael J. Yourishin, audio/visual specialists from Prince George's County Executive's Office, Communications Department; Ellen B. Amey, co-chair of the History and Records Ministry of St. Paul United Methodist Church; Everett Earl Washington, National Archives and Records Administration (Archive II); and Frank and Luella Bailey. Finally we extend gratitude to Maurice Thomas, who provided professional expertise in information technology, writing, editing, and photography; Jocelyn Gee Miles for taking pictures of markers, signs, and buildings in Forest Heights and Oxon Hill; Bonita Anderson and George F. Wiggers for their information on the town of Forest Heights; and Carla Henry Rosenthal, James E. Mills Jr., Phyllis and Arthur Cox, James Kane (historian from the General Service Administration), Jane Klemer, and Jim Rosenstock for their contributions of personal oral histories and photographs.

INTRODUCTION

The Oxon Hill District, an unincorporated community in southern Prince George's County, Maryland, is a suburb of Washington, D.C. There are no official boundaries for the Oxon Hill District, which includes the incorporated town of Forest Heights and the unincorporated communities of Glassmanor and Eastover. The U.S. Census Bureau established a census-designated boundary consisting of Oxon Hill and the adjacent community of Glassmanor. Oxon Hill has many features and attractions, such as Rosecroft Raceway, Henson Creek Golf Course, several elementary, middle, and high schools, and a modern public library. Oxon Hill–Glassmanor contains 2,977 acres of land located along the south side of the Capital Beltway between Indian Head Highway and Henson Creek.

Prince George's County was established in 1695, and in 1874, Oxon Hill became part of the Piscataway Hundred, embracing the southwestern section of the county along the Potomac River, from Oxon Run to Mattawoman Creek. The Oxon Hill District was largely a rural farming district that did not focus its crops on tobacco. The mainstay of Oxon Hill farms was corn, wheat, and other agricultural products. In 1980, the Oxon Hill population was 16,800, with more than 6,500 dwelling units. Oxon Hill never developed in the same way that Upper Marlboro, Greenbelt, and other communities propagated, as it maintained some of the rural beauty of farmland, single-family homes, townhouses, and a few parcels of land zoned for apartment development.

In 1667, John Addison came to the New World and settled on the estate that had been granted to him by the king of England. The geographical setting of this land was so similar to the land surrounding his alma mater, Oxford University, that he decided to call it Oxford on the Hills, but later it was shortened to Oxon Hill.

In 1695, the St. Elizabeth's land tract passed to Col. John Addison and became a part of his extensive landholdings along the Potomac. One of the Addison descendants later changed the name of the community and manor to Oxon Hill. Other Addison family members continued to live in the area at Barnaby Manor on Barnaby Run (near the intersection of Owens and Wheeler Roads).

Little-known facts about Oxon Hill:
- Oxon Hill was one of the original hundreds.
- Oxon Hill is District 12 of the modern Prince George's County structure.
- Oxon Hill is the burial ground for one of the most prominent figures in the Colonial period—John Hanson.
- Oxon Hill was one of the sites considered in 1789 for the capital of the United States.
- Oxon Hill was on the old "Alexandria Ferry Road."
- Oxon Hill's Fort Foote was one of the forts that helped protect the federal city during the Civil War.
- The first Oxon Hill Manor was destroyed by fire in 1895, and the current manor was built in 1929 by Undersecretary of State Sumner Welles, a cabinet member of Franklin Delano Roosevelt.

One

OXON HILL

Oxon Hill is located southeast of the nation's capital in Prince George's County, Maryland. The name, Oxon Hill, derives from an alumnus of Oxford University, John Addison. Since the geographical surroundings resembled the land at Oxford University, Addison called it "Oxford on the Hill." Later the name was shortened to Oxon Hill. The property was later parceled off to tenant farmers. Oxon Hill Manor, or the Addison Plantation as it was sometimes called, was a large agricultural plantation occupied from the early 18th through the early 20th centuries in southern Prince George's County. Oxon Hill Manor sits on top of a hill with a picturesque view of the Potomac River. The grounds include formal gardens, rose bushes around a reflecting pool, and a large brick patio for outdoor seating. Featured inside are exquisitely appointed rooms with wood floors, crystal chandeliers, and fireplaces. A sweeping circular staircase ascends from the first-floor hallway. The Maryland–National Capital Park and Planning Commission now owns Oxon Hill Manor. It is leased to the Oxon Hill Manor Foundation. The foundation raised funds for renovation of Oxon Hill Manor when it started deteriorating.

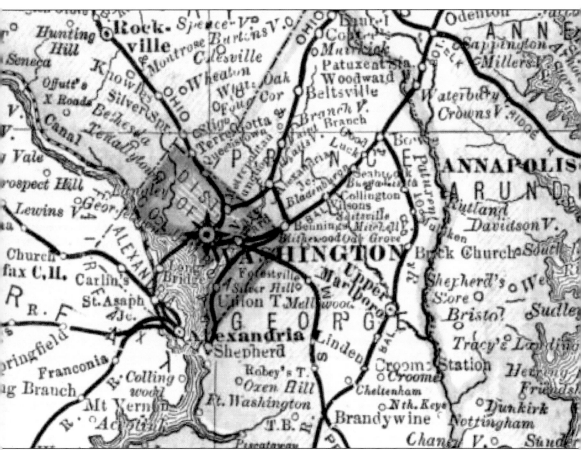

This is a map of Oxon Hill as it existed in the mid-19th century. The boundaries were the Potomac River, the District of Columbia line, Spaulding's District (26th Avenue, Southern Avenue, and Temple Hills Road), Surratt's District (Allentown Road, Tucker Road, and Palmer Road), and Piscataway District. (Courtesy of http://alabamamaps.ua.edu/historicalmaps/maryland.)

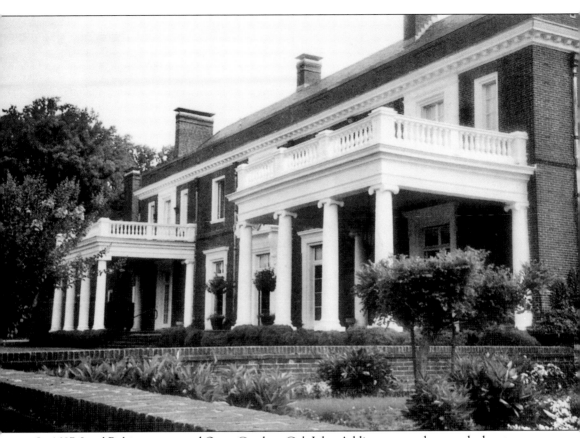

In 1687, Lord Baltimore granted Oxon Creek to Col. John Addison, a merchant and adventurer. In 1706, Thomas Addison, son of Colonel Addison, inherited the land. Thomas Addison built one of the finest brick mansions that overlooked the Potomac River. In 1767, the land was patented as Oxon Hill Manor. The site successively transferred to generations of the Addison family, who lived on the estate until 1810, when Walter Dulaney Addison sold most of the original property to Zachariah Berry. Upon the death of Berry, his son, Thomas, inherited the mansion. Thomas was found mentally incompetent, and the property was placed in trustees to be sold for the payment of debt. In 1888, the Berrys sold the remainder of the land to Samuel Taylor Suit. However, in 1895, a fire destroyed the original mansion. (HABS, Courtesy of the Library of Congress, Prints and Photographs Division.)

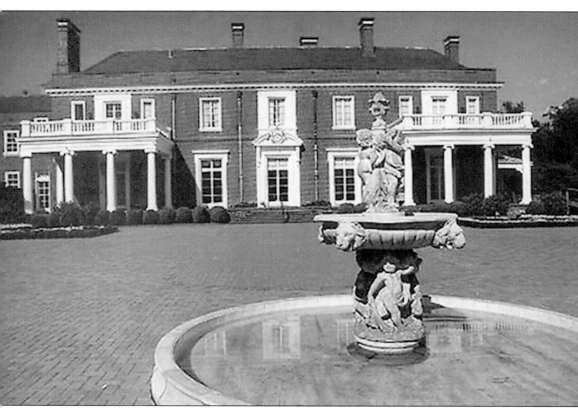

Around 1928, Sumner Welles, a career diplomat and the undersecretary of state during Franklin D. Roosevelt's administration, purchased 245 acres of Oxon Hill Manor and built a 49-room Georgian-style manor house, designed by Count Jules Henri de Sibour. Roosevelt frequently visited the estate. The land and former mansion were home to the nephews of George Washington and John Hanson, the first president elected by the Continental Congress under the Articles of Confederation. Hanson visited Oxon Hill Manor often and died there in 1783. It is believed that Hanson was buried in the estate's cemetery. In 1952, Fred Maloof acquired the estate and established a museum for fine art and John Hanson memorabilia. (HABS, Courtesy of Library of Congress, Prints and Photographs Division.)

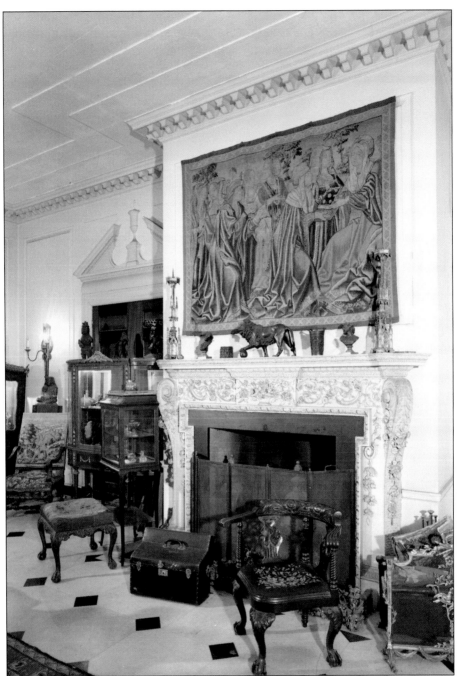

Guests of the original manor gained access to the elegant dining room from the library, and the lateral hall, west terrace, and service wing pantry occupied northwest corner of main block. Occupants of the mansion enjoyed the ambiance while dining. One could dine in a unique atmosphere surrounded by antique furnishing, an elaborate wooden mantelpiece in the Georgian style, ornate decorative mirrors, and busts and figurines of Pres. George Washington and John Hanson, as well as other notables. (HABS, Courtesy of the Library of Congress, Prints and Photographs Division.)

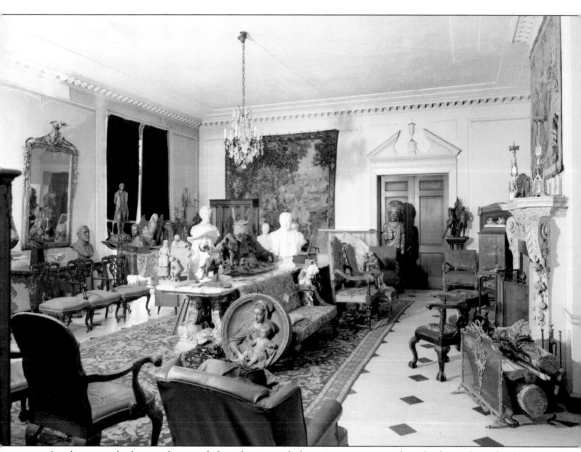

In the years before widespread distribution of electric power, people relied on their fireplaces for warmth, comfort, and the preparation of food. In Oxon Hill Manor, all principle rooms and chambers had fireplaces. The entrance hall in the mansion had a very elaborate wooden Georgian mantelpiece. The term Georgian refers to the historic period of all the ruling King Georges of England and Ireland from 1714 to 1830. Fireplaces in the living quarters became smaller and more efficient, since they were used for heating only, and the large hearth could be confined to the kitchen only. (HABS, Courtesy of the Library of Congress, Prints and Photographs Division.)

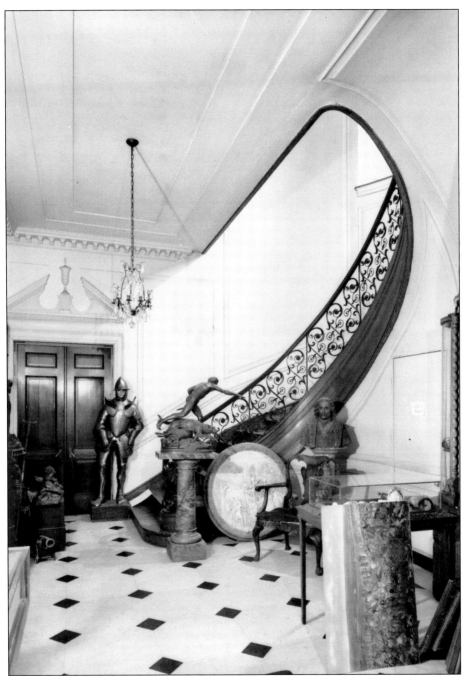

Oxon Hill Manor's main stairs ascend 27 risers (a vertical part of a step or stair) to the second floor in a semicircle running east to west. The railing consists of oak and wrought-iron, 8-shaped scrolls of foliated patterns. The railing and its supports turn at the bottom to form a newel post of volute plan resting on curtail steps. In comparison, the steps used by slaves were made of steel and concrete, ran east 4 risers to a landing, south 13 risers to the second landing, and west 3 risers to the second floor. (HABS, Courtesy of the Library of Congress, Prints and Photographs Division.)

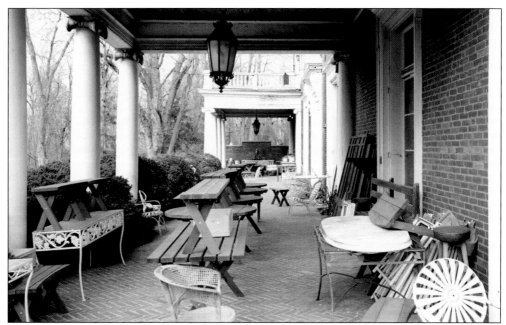

Associated with the mansion are brick terraces that rest on earthen fill. The terrace is paved in a herringbone pattern. It extends beyond the south elevation to connect with the west terrace and does not have a balustrade (banister). A similar porch spans the first floor of the service wing. Under the north and west terraces, a coal storage space once existed that furnished heat for the mansion. (HABS, Courtesy of the Library of Congress, Prints and Photographs Division.)

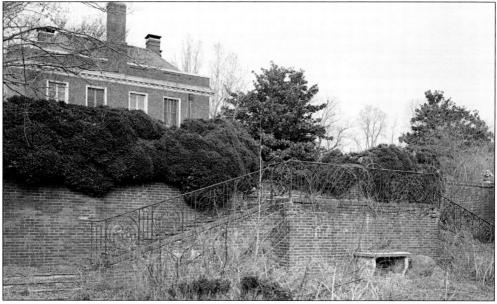

The gardens have been neglected, but part of the lawn terrace and planting arrangement are still evident. The lawn extends to the west until it merges with woodland. The formal gardens are west of the house. The garden and lawn are separated by a steep slope and plant material. Entrance grounds are wooded, with specimen trees and shrubs near the drive and building. (HABS, Courtesy of Library of Congress, Prints and Photographs Division.)

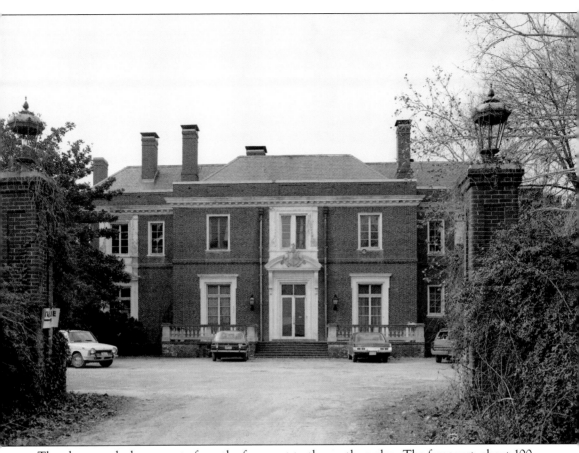

The photograph shows a gate from the forecourt to the south garden. The forecourt, about 100 feet by 100 feet at the entrance to the house, is enclosed by an approximately 10-foot-high brick wall. Photographs dating from the Welles period (1930s and 1940s) show that the forecourt was once enclosed with an iron fence supported by brick piers. Piers flanking the drive entrances are surmounted by wrought-iron lanterns and those next to them topped by cast-stone pineapples. (HABS, Courtesy of the Library of Congress, Prints and Photographs Division.)

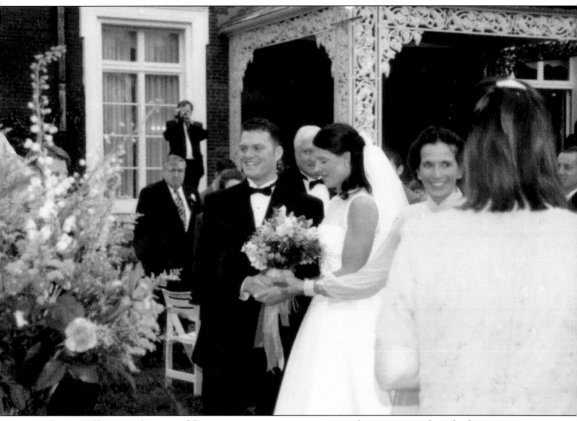

Oxon Hill Manor hosts weddings, receptions, meetings, art shows, arts and crafts fairs, concerts, dances, and other social events. As an example, Michael and Genevra Guagliano's wedding took place in this spectacular English garden. In early spring of 2000, the Guaglianos' wedding was held on the landscaped grounds with its manicured, sculptured lawns and blooming flowers. The Potomac River, which flows into the Chesapeake Bay, served as a background for this beautiful affair. (Courtesy of the Guagliano collection.)

Two

Oxon Hill Cove and Oxon Hill Farm

Oxon Cove Park and Oxon Hill Farm are located in the District of Columbia and Prince George's County, Maryland. Oxon Cove Park provides a variety of recreational activities and serves as a scenic natural/urban transition for the southern gateway to Washington, D.C. The portion of Oxon Cove Park in Prince George's County was originally acquired for inclusion in the Maryland portion of the George Washington Memorial Parkway and was to continue southward to Fort Washington. The primary feature of Oxon Cove Park is Oxon Hill Farm, which operates as an actual working farm representative of the early 20th century. Since the 17th century, the Oxon Hill area has attracted men and women who recognized its agricultural potential. Estates raised tobacco, cattle, wheat, corn, and fruit as cash crops for nearby developing urban areas. Much of the labor for these early plantations was provided by slaves. Later the area was divided into smaller working farms. Visitors have the opportunity to visit a farmhouse, barns, a stable, feed building, livestock buildings, and a visitor activity barn. It exhibits basic farming principles and techniques as well as historical agricultural programs for urban people to develop an understanding of crop raising and animal husbandry.

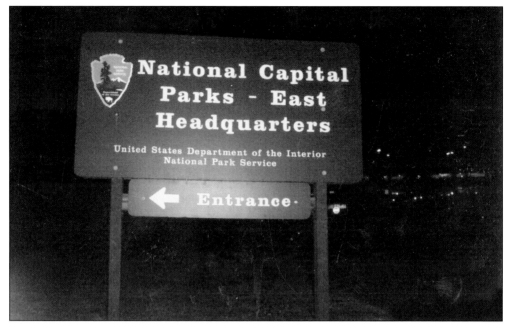

The entrance sign to the National Capital Parks East headquarters is located in Anacostia Park in Southeast Washington. The national parks run by the National Park Service, a part of the U.S. Department of the Interior. Historian Frank Faragasso works in the park's library. (Courtesy of the Miles collection.)

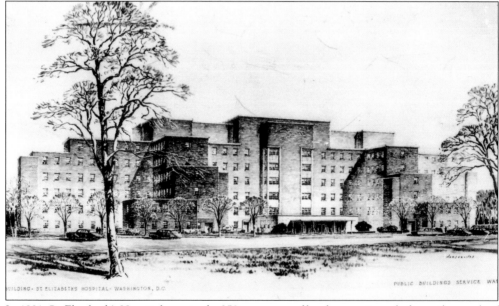

In 1891, St. Elizabeth's Hospital acquired a 350-acre tract of land approximately five miles south of the main institute in the Oxon Hill District of Prince George's County. Dr. William W. Godding incorporated this new property, called Godding Croft, as an expansion of agricultural facilities at the hospital to provide fresh food and a therapeutic way to move the "harmless insane" to work outside the confines of the hospital grounds. (Courtesy of the Martin Luther King Jr. Library, Washingtoniana Collection.)

The St. Elizabeth's Hospital campus houses a Victorian fire station with a clock tower that doubled as a place to dry hoses and a windowless icehouse made of fieldstone. Clock towers are usually part of a church or municipal building such as a town hall, but many clock towers are free-standing. (Courtesy of the Jane Klemer collection.)

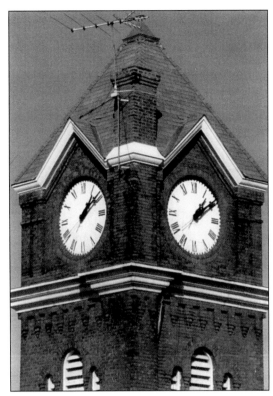

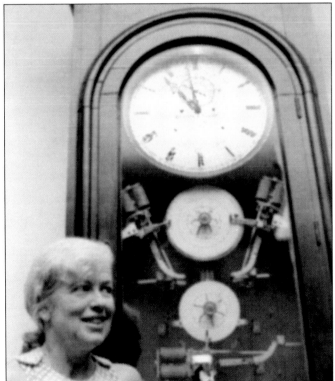

Jane Klemer, a retiree from St. Elizabeth's Hospital in Washington, D.C., stands by the 1868 clock tower in the center of the building. The clock records telegraphic signals (on the lower two disks) sent by patrolmen from their stations. The clock occupies a space about six feet square and is housed in a cast-iron frame that bolts to the floor. Ms. Klemer was responsible for the clock. (Courtesy of the Jane Klemer collection, photograph by Merlin Paulson.)

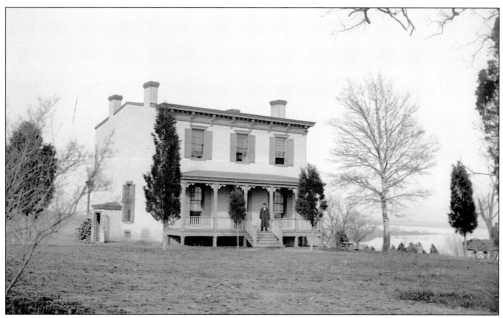

Mount Welby is the principle dwelling on the property of Oxon Cove Farm. The two-story, three-bay brick structure sheltered by a shed roof is a historic house, built *c.* 1807. The white house at the top of the hill served as a dormitory for St. Elizabeth's patients who worked at the farm from 1891 to the mid-1950s. The house was built on the hill to be cooled by the constant breezes from the Potomac River. The house now serves as offices and exhibits. (Courtesy of the National Park Service.)

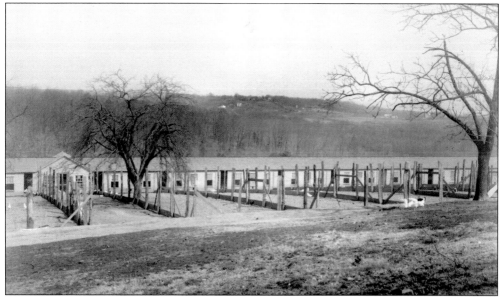

This 1914 photograph is of the hennery at Godding Croft, a part of St. Elizabeth's working farm that produced fresh eggs and poultry for the hospital as well as providing a healthful and instructive occupation for the patients. During one 20-year period, the farm switched from White Leghorn laying hens to Plymouth Barred Rocks to New Hampshire Reds. (Courtesy of the National Archives and Records Administration.)

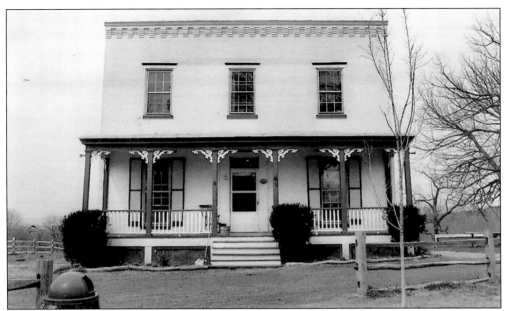

Mount Welby, a historic landmark on the Oxon Hill Farm, is centrally located high above the Potomac River just north of the Capital Beltway and is visible from the Woodrow Wilson Bridge in Alexandria, Virginia. The land surrounding the house was part of Oxon Hill Manor until it was sold by Rev. Walter Dulaney Addison to Nicholas Lingan in 1797. In 1891, under the ownership of the federal government, the house served as a residence for some of the hospital patients working on the Godding Croft farm. (Courtesy of National Archives and Records Administration.)

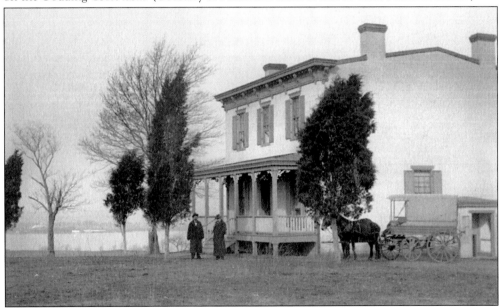

A photograph of Godding Croft c. 1893 depicts Mount Welby, two people, a horse, and a wagon. Dr. Samuel DeButts acquired the house about 1811 and renamed the property Mount Welby in honor of Mary DeButts's family. The DeButts family owned more than 10 slaves. The Mount Welby tract eventually comprised the northern section of Oxon Cove Park. (Courtesy of National Archives and Records Administration.)

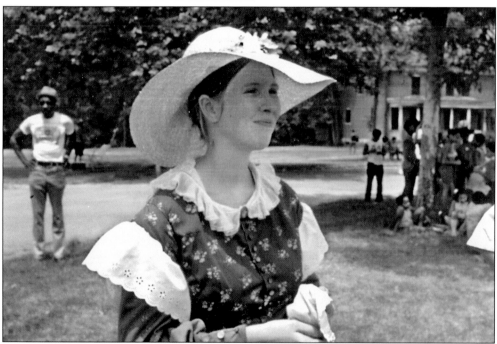

This exhibit at Mount Welby includes the manumission papers of John and Netty Ganor. The mystery surrounding the Ganors' association with the DeButts family is answered because there is no documentation to reflect ownership. John served the DeButts family as a driver, and his wife, Netty, worked in the house as a cook. (Courtesy of the Maryland Archives.)

In front of Mount Welby, a lady is dressed in period clothing during one of the summer festivals on the Oxon Hill Farm. This picture was taken in 1967. A worker is looking on. (Courtesy of the National Park Service.)

Reenactors dressed in period clothing are on the front porch of Mount Welby, home to John DeButts and family. Reenactors animate the history and honor the memory and sacrifice of those who served during the Civil War as authentically as possible. (Courtesy of the National Park Service.)

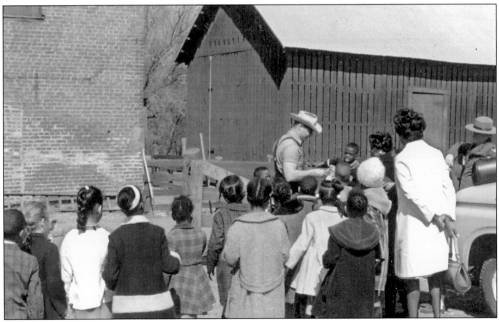

A park ranger looks on as a farm employee shows the children some of the animals and explains their function to the farm. The employee is letting one of the boys touch the animal. They are standing outside of the brick barn behind the fence. (Courtesy of the National Park Service.)

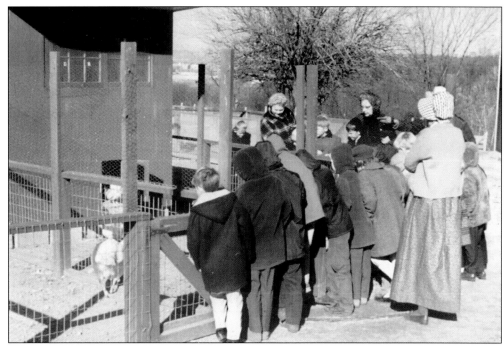

Occasionally the farm has volunteers who dress in period clothing and give tours to schoolchildren. Here a class is looking at the chicken house, where young hens are parading around their pen. (Courtesy of the National Park Service.)

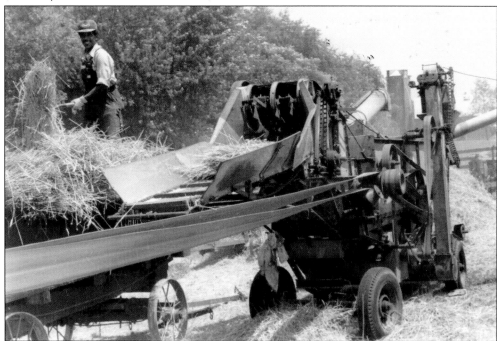

A farm employee works the bailer, collecting hay for storage. Oxon Hill Park provides an excellent resource for environmental studies, wildlife observing, fishing, and other recreational activities made possible by easy access to the Potomac River. (Courtesy of the National Park Service.)

Oxon Hill Farm is home to a windmill. The windmill was used to pump water out of a well. In the United States, windmills were a necessity on most farms and ranches. There are many varieties, brands, and sizes for visitors' viewing pleasure at farms and museums around the nation. (Courtesy of the National Park Service.)

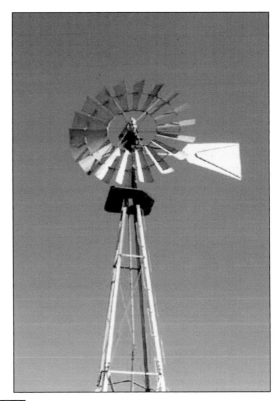

In 1967, the Oxon Hill Children's Farm opened up to children, schools, and general visitors. Here children from a local Brownie troop are gathered around the big red barn, where they can view the animals. A park ranger is explaining the operations of a working farm. (Courtesy of the National Park Service.)

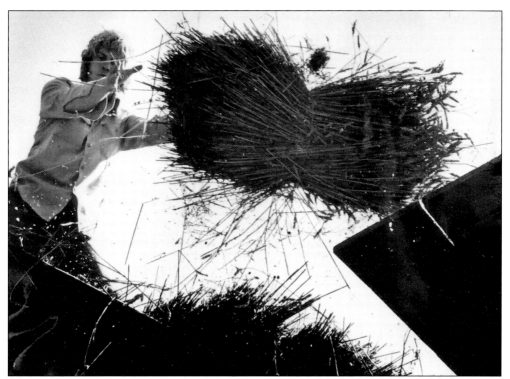

A sheaf of wheat is tossed to the thresher (right) in the Oxon Hill Children's Farm demonstration of the threshing process used at the turn of the century. Visitors take turns in a bale-throwing competition. (Courtesy of Martin Luther King Jr. Library, Washingtoniana Collection.)

The hay barn is used for storage of hay and straw. Bales of hay, a dry forage crop used as animal feed, especially during the winter, are stored in the hay barn. Straw, the stalk of grain plants, is used for animal bedding. One side of the barn is used for an activity program when not needed for hay storage. (Courtesy of the National Park Service.)

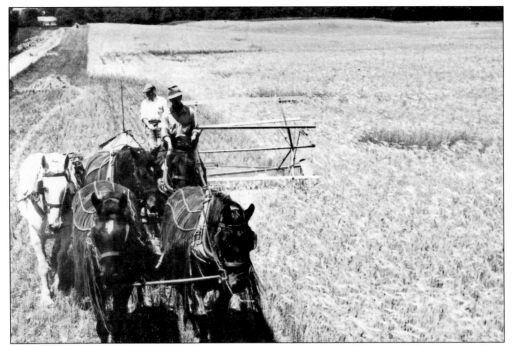

The Oxon Hill Children's Farm uses a 19th-century, horse-drawn steam-powered threshing machine to demonstrate the process of separating grain from the wheat. The farm maintains a stable of horses year-round. (Courtesy of the Martin Luther King Jr. Library, Washingtoniana Collection.)

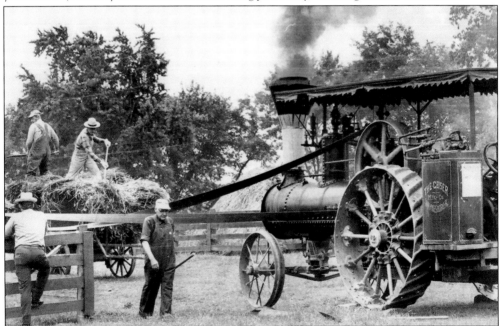

In the early days before everything became plastic, the steam-driven threshing machine was a staple of farm life, hissing from farm to farm to get in the wheat harvest. This hand-fed thresher, built in 1921, demonstrates how it used to be done on eight acres of wheat grown on the Oxon Hill Farm. (Courtesy of the Martin Luther King Jr. Library, Washingtoniana Collection.)

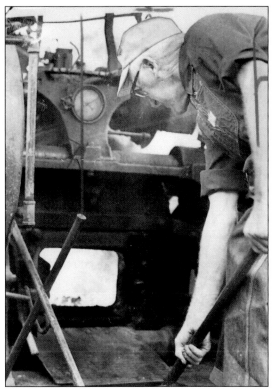

As wheat is pressed to the thresher, power is provided by the 50-horsepower engine. Raymond L. Young, age 72, of Westminster, Maryland, who worked on such machines in his youth, stokes the ancient engine with coal as he demonstrates how to use it. (Courtesy of the Martin Luther King Jr. Library, Washingtoniana Collection.)

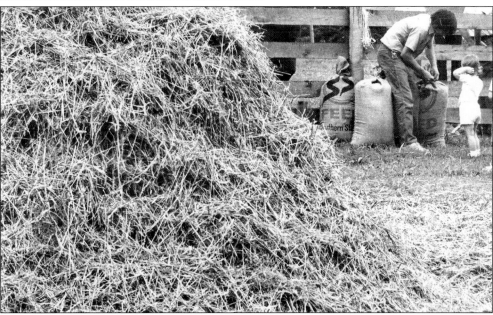

A parent shows her child how to pack hay in sacks. As a rule, the first cut of hay, made in May or June in the bloom or boot stage, is the best, but it is often difficult to make hay at this time because of cool or wet weather. When hay is cut in late July and August, it contains a lot of seed-stem straw. In the photograph, the hay is stacked outside of the hay barn until it is processed for storage in the barn. (Courtesy of the National Park Service.)

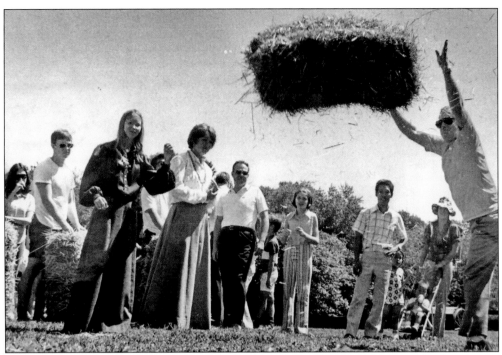

Ralph Shirtzinger tries his skill at tossing a bale of wheat. The wheat grown at the farm by the National Park Service farmers is hauled by horse-drawn wagons to the steam-powered threshing machines. The machine, typical of those used in earlier years, separates the grain from the chaff at the farm. (Courtesy of the Martin Luther King Jr. Library, Washingtoniana Collection.)

Oxon Cove Park overlooks the historic Potomac River and tells the story of how the use of land has changed through the years. The park includes a farm house, barns, a stable, a feed building, livestock buildings, and a visitor activity barn. Oxon Hill Cove welcomed its first visitors in 1967 and continues to tell the diverse story of the land and its use over time. This winter view shows the farm buildings in all their glory. (Courtesy of http://www.nps.gov/nace/oxhi/index.htm.)

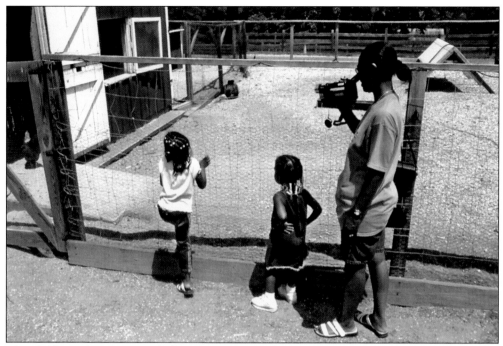

The children's farm is opened all year round, and children are encouraged to come with their schools and with their parents to see the animals at a working farm. Here are two young girls trying to see the chickens inside the barn. (Courtesy of the National Park Service.)

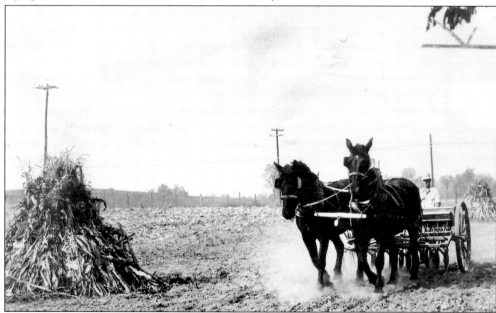

The Oxon Hill Farm demonstrates how the average farmer seeded his winter wheat with horse-drawn wagons. Under the direction of the National Park Service, the farm represents farm life of the 1898–1914 period. Regular demonstration activities such as wheat threshing, horse team plowing, and cow milking are held throughout the year. (Courtesy of the Martin Luther King Jr. Library, Washingtoniana Collection.)

The Oxon Hill Farm history begins with the family of Col. John Addison, his son and grandsons, and their descendants, who with their slaves built the original Oxon Hill Manor and other buildings. The farm has changed owners over the years, but it has always remained a working farm that provided a good living. Today the farm is representative of early-20th-century rural living. It exhibits basic farming principles and techniques as well as a historical agricultural program for urban people to develop an understanding of crop raising and animal husbandry. (Courtesy of http://www.nps.gov.)

The Oxon Hill Farm Museum contains period farm equipment, tools, and machinery. The museum staff and volunteers harvest apples and grow herbs, squash, tomatoes, and other standard market vegetables, which are sold from a roadside farm stand. Educational tours and workshops cover horticultural technology, farm life history, and food preparation. The museum is housed in the red barn. (Courtesy of the National Park Service.)

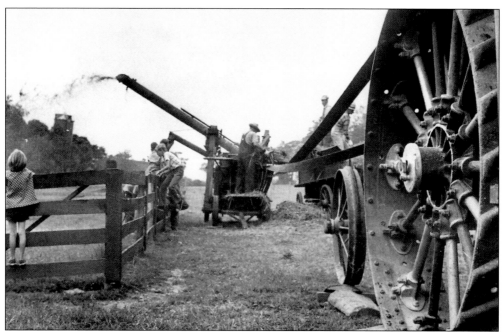

A side view shows National Park Service (NPS) farmers at the Oxon Hill Children's Farm working the wheat into the steam-engine threshers. NPS personnel who serve as interpreters wear traditional farm attire of the early 20th century. The dress code consists of bib overalls, straw hat, and blue shirt for men, and full calico dress and sunbonnet for women. (Courtesy of the Martin Luther King Jr. Library, Washingtoniana Collection.)

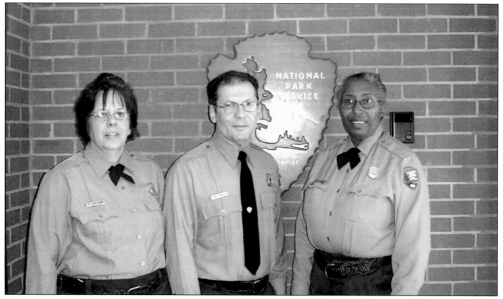

From left to right, ranger Marilyn Brown, Dr. Frank Faragasso, and ranger Vanessa Molineaux enjoy time outside the National Park Service East headquarters in Southeast Washington, D.C. Ranger Molineaux works with Dr. Faragasso in preserving the historical character of the Oxon Hill Farm buildings and property. Together they work to develop and organize training courses for a variety of visitors at the Oxon Cove Park and Oxon Hill Farm. (Courtesy of the National Park Service.)

Three

St. Paul United Methodist Church

St. Paul United Methodist is thought to be the oldest black congregation in the Baltimore Conference. It began its glorious history with dedicated worshippers who rejoiced in the church's legacy of administering to the spiritual needs of a community. In October 1791, some slaves invited a white Methodist circuit preacher, Rev. Ezekiel Cooper, to speak to a small congregation. Reverend Cooper preached in Oxen Hill (Oxon Hill) in a small house that had been built by a number of religious black people. Since that time, the church entertained a number of pastors and was situated on several sites, including behind the present Oxon Hill Post Office. In 1863, slave owners seized their meetinghouse and forbade further assemblies. Consequently, they had to relinquish the old building and worship in the homes of members. In 1865, the Freedmen's Bureau provided the funds to build a school, which could be used as a place to worship. Brother Henry Hatton donated the land, which was located between Oxon Hill Children's Farm and the town of Forest Heights, and the people paid for the erection of the school. St. Paul consists of a well-educated, middle-class congregation and has become a political force in Prince George's County.

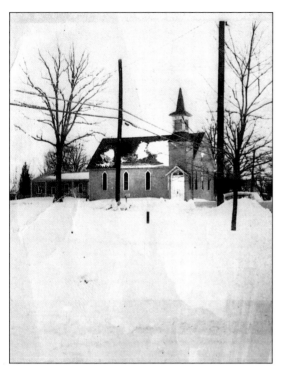

Dr. Nathaniel Carroll, one of the original members of the Washington Conference when it was organized in 1864, preached the first sermon in the new St. Paul Methodist Church. The old brick building stood behind the site of the Oxon Hill Post Office on Oxon Hill Road. In 1870, Rev. Daniel Wheeler became pastor of St. Paul, and he was reappointed for another year in 1871. He returned to St. Paul as pastor in 1888. In 1925, the cornerstone for the old St. Paul Church, now the chapel, was laid during the pastorate of Rev. Victor Johnson. Between 1920 and 1965, 15 ministers pastored at St. Paul United Methodist Church. (Courtesy of the St. Paul United Methodist Church History and Records Ministry.)

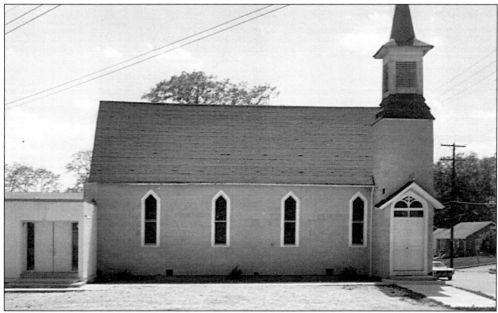

In the 1920s and 1930s, racial discrimination so plagued Oxon Hill that only a handful of blacks who lived near the church came to worship. Additionally the church suffered financial difficulties. The church became run-down and dilapidated throughout the 1950s and 1960s. However, in 1979, the United Methodist Union, a part of the Baltimore Conference of United Methodist Churches, gave St. Paul $5,000 and a $23,000 loan under a program designed to help the growth of small ethnic and minority churches. Church members contributed time and efforts to the renovation. (Courtesy of the St. Paul United Methodist Church History and Records Ministry.)

Eston and Thelma Tanner were loyal parishioners of St. Paul from the 1930s until their deaths. On November 14, 1937, they joined hands in matrimony. From 1939 to 1943, they resided in Washington, D.C. After Eston served a two-year tour of duty in the armed services, the Tanners returned to Oxon Hill. Eaton worked diligently in the church, serving as superintendent of the Sunday school and coordinating the Methodist Youth. Thelma was appointed a trustee of the church and served as the Methodist Youth coordinator and advisor. (Courtesy of the St. Paul United Methodist Church History and Records Ministry.)

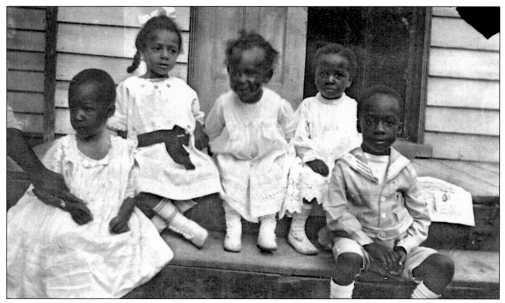

From left to right are unidentified, Harriet Butler, Thelma Smith Tanner, Lucille Thompson, and Carl Thompson. This photograph was taken in the early 20th century on the steps of an old church located across the street from St. Paul United Methodist Church. All of the children became faithful parishioners and contributors of the church. They participated in Sunday school, youth ministry, church choir, and other notable events. (Courtesy of the St. Paul United Methodist Church History and Records Ministry.)

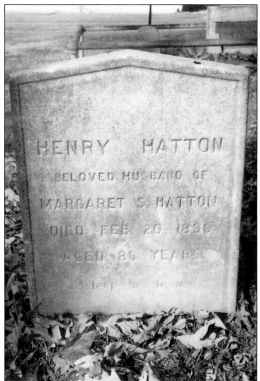

In October 1840, according to the will of the late Mrs. Henry C. Hardey, Henry Hatton became a free man at the age of 28. A former slave, Hatton became a leader in the rural Prince George's County community. He worked as a blacksmith. Because of his interest in education, his family initiated the first efforts to establish a school for freedmen at Oxon Hill. Hatton died on February 20, 1896, at the age of 86. He is buried in St. Paul Cemetery. (Courtesy of the St. Paul United Methodist Church History and Records Ministry.)

In 1888, St. Paul United Methodist Church, originally standing where the Fellowship Hall is located, moved to its present site. Dr. Nathaniel Carroll preached the first sermon in the new church. Rev. Daniel Wheeler, who was the pastor in 1870, returned as pastor of St. Paul. During the period 1890–1912, nine ministers pastored at the church. Of the nine ministers, Rev. William H. Dean, pictured at right, and others faithfully served the church by performing baptisms and marriages, as well as presiding over requested services. (Courtesy of the St. Paul United Methodist Church History and Records Ministry.)

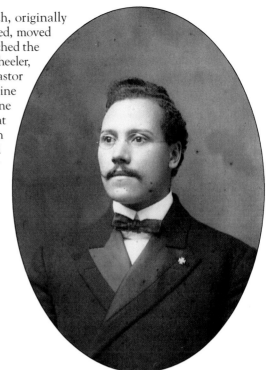

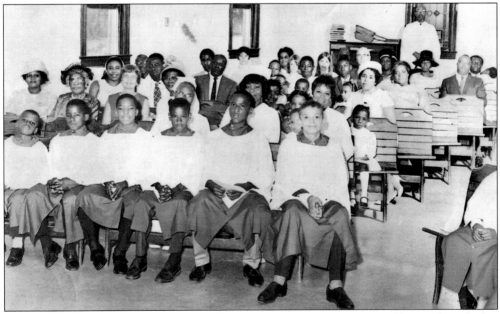

From 1966 to 1969, Rev. John A. Shirkey, then associate pastor of Oxon Hill United Methodist Church, was appointed minister of St. Paul. He was one of two white pastors of a black congregation in the Baltimore Conference of the Methodist Church. Reverend Shirkey and his wife, Jean, worked diligently, especially in the organization of the youth. The church held numerous ecumenical services, and a joint meeting took place between the parish and churches. (Courtesy of the St. Paul United Methodist Church History and Records Ministry.)

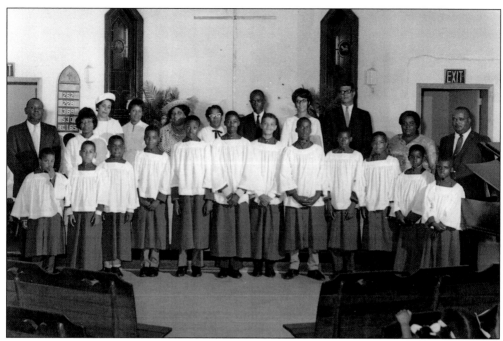

In 1970, members of St. Paul United Methodist Church First Acolytes gathered at Sunday service. Acolytes are boys and girls (ages 9 to 12) who serve during the worship hours assisting the pastor and church. Shown here from left to right are the acolytes and their parents: (first row) Kevin Hill, Gary Savoy, Barry Hill, Osmond Johnson, Howard Jenkins, Samuel Gillian, Harry Vactor Jr., Michael Stocks, Aubrey West, Jerry Johnson, Kevin West, and Richard Meyers Jr.; (second row) Willie B. Hill, Mary Savoy, Evelyn Hill, Ruth Johnson, Julia Thomas, Sarah Jenkins, Glennie Jenkins, Betty and Harry Vactor Sr., Catherine Stocks, and Richard Meyer Sr. (Courtesy of the St. Paul United Methodist Church History and Records Ministry.)

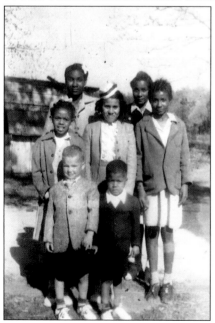

A parent shot this photograph in 1934 of the children on their way to Sunday school at St. Paul Methodist Episcopal Church. The Sunday school provides education and biblical study for all age groups in the church. From left to right are (first row) Donald "Pewee" Proctor and Rudolph "Jap" Proctor; (second row) Charlotte Diggs, Dorothy Burch, and Josephine Sims; (third row) Mary Sims Proctor and Rosie Sims. (Courtesy of the St. Paul United Methodist Church History and Records Ministry.)

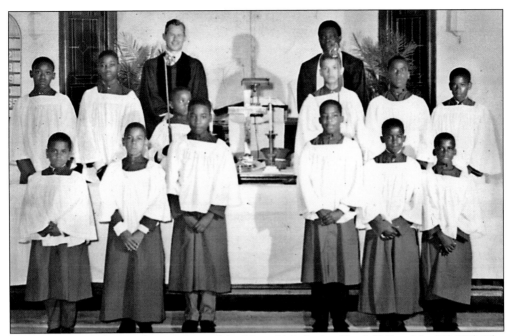

This photograph depicts the members of the United Methodist Youth Fellowship (UMYF). The UMYF is an organized group of youth (ages 12 to 18) within the church. The UMYF is open to all youth seeking to know Jesus Christ and to participate in the total ministry and mission of the church and community. (Courtesy of the St. Paul United Methodist Church History and Records Ministry.)

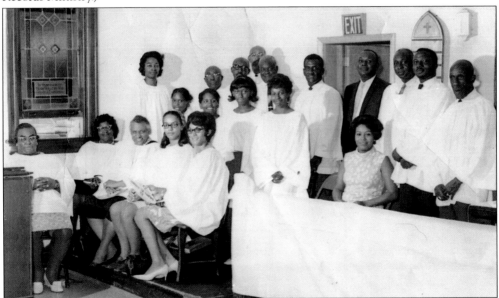

The earlier choir of St. Paul United Methodist Church was coeducational, with males and females from the community. Seated against the wall is Thelma Tanner, one of the pianists, who assisted Andrea Robinson, the director of music. Since this was a small church, the members served in a number of capacities in order to support the music ministry. Today the choir is much larger. (Courtesy of the St. Paul United Methodist Church History and Records Ministry.)

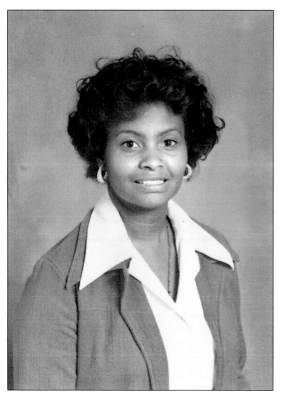

This is a photograph of Ellen B. Amey in the early 1970s. She arrived from North Carolina and settled in Oxon Hill. Amey joined St. Paul United Methodist Church at the age of 36. She serves as the church historian, who documents, preserves, and records the historical data of the church and its ministry. (Courtesy of the St. Paul United Methodist Church History and Records Ministry.)

Two unidentified members of St. Paul United Methodist Church posed for a photograph after Sunday service. The two individuals were close friends who had been associated since childhood. The friends supported each other and their families. (Courtesy of the St. Paul United Methodist Church History and Records Ministry.)

Mrs. Alice Lewis joined St. Paul United Methodist Church in 1944. She was born in 1912 in North Carolina. Mrs. Lewis served the church and the community until her death in April 1985. She is survived by her daughter, Mary Savoy, who lived in Birchwood City near the Oxon Hill Shopping Center. (Courtesy of the St. Paul United Methodist Church History and Records Ministry.)

On Sunday, November 8, 1942, St. Paul United Methodist Church members participated in the dedication exercise of the Oxon Hill Colored School. The theme was "educating for victory in the community-centered school." Rev. C. B. Ashton, pastor of St. Paul, delivered the invocation. Alice Thompston, president of the local Parents-Teacher Association, welcomed all invitees. Vincent A. Osterman, associate judge of Orphan's Court, provided greetings. Doswell E. Brooks, supervisor of colored schools for Prince George's County, presented the school to the community. After the dedication and naming of the school, the audience sang the Negro National Anthem. (Courtesy of the St. Paul United Methodist Church History and Records Ministry.)

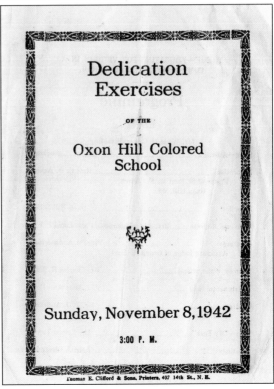

Dedication
Exercises

OF THE

Oxon Hill Colored
School

Sunday, November 8, 1942

3:00 P. M.

Thomas E. Clifford & Sons, Printers, 407 14th St., N. E.

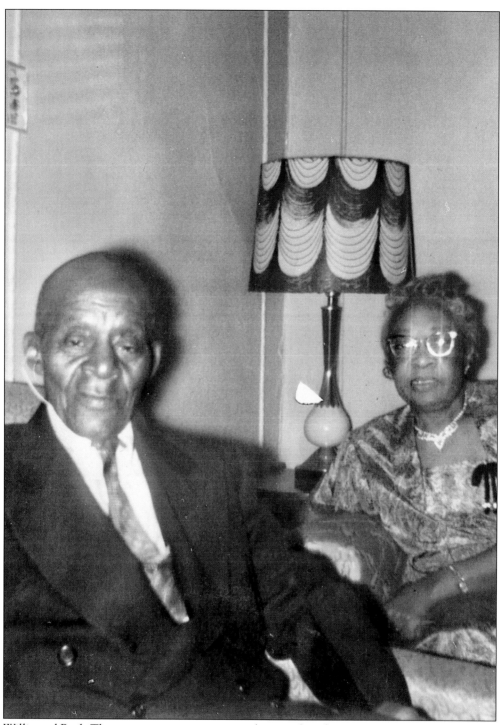

Willie and Ruth Thompson enjoy an evening at home. The Thompsons were faithful members of St. Paul United Methodist Church. Ruth embroidered linen scarfs at her home on Bock Road. She served the church until her death. (Courtesy of the St. Paul United Methodist Church History and Records Ministry.)

Four

CHURCHES AND CEMETERIES

Throughout history, churches have played a significant role in African American communities in areas that extend beyond religion and impact education, economics, government affairs, and a wide range of social issues. Many of the churches in the early Oxon Hill communities included mixed-race congregations. Most of those churches set aside a portion of church property for a cemetery; however, not all of these burial grounds permitted burial of their black church members. The churches in Oxon Hill reflect a wide variation in architectural styles; many of the original structures have been modified, renovated, or completely rebuilt.

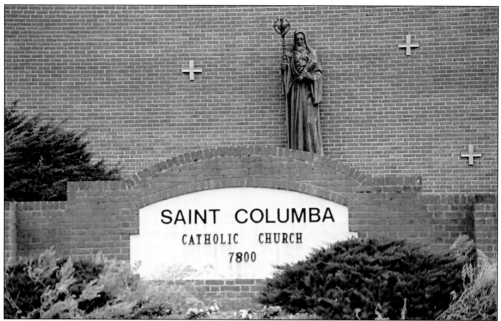

On December 7, 521, St. Columba (or in Gaelic, Columcille), the most famous saint to spread the faith in Scotland, was born. Accordingly Columba was an important part of that time in Irish history that produced her three greatest saints: Patrick, Brigid, and Columba. Since both of his parents were of royalty, he was eligible for the high kingship of Ireland. Instead he chose to dedicate himself to the service of God. On June 9, 591, St. Columba's brother monks found him dying in church before the altar. (Courtesy of the St. Columba Parish collection.)

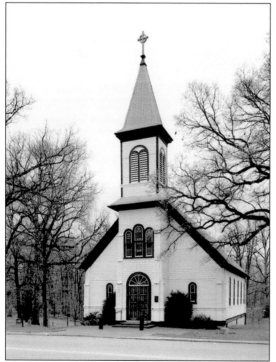

For more than a century prior to the establishment of St. Columba Parish, the same clergy from St. Ignatius Parish served Catholics in the Oxon Hill area. On July 1, 1955, the Archdiocese of Washington, D.C., purchased 11.417 acres of land on Livingston Road in Oxon Hill as the site for St. Columba Parish and school. Archbishop Patrick Aloysius O'Boyle decreed the "canonical erection" of the parish as of June 18, 1960. St. Columba Parish was formed from St. Ignatius Parish, which had a population of about 322 families at that time. (Courtesy of the St. Columba Parish collection.)

46

St. Columba held Sunday mass in an auditorium at the Oxon Hill Junior High School. On June 19, 1960, Fr. Milton A. Schellenberg, first pastor of St. Columba, said the first two masses. In December 1960, a plan for the first unit of construction of a church and school was drawn up by Andrew MacIntire, an architect, and Father Schellenberg. The first unit, Tudor Gothic in style, combined a chapel and a separate social hall. (Courtesy of the St. Columba Parish collection.)

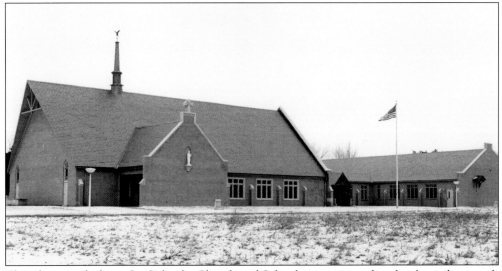

This photograph shows St. Columba Church and School as it exists today, thanks to the growth of the parish and suitable finances. The church provides additional school facilities and space for meetings and special events to more effectively carry out parish functions. St. Columba offers parishioners of all ages and nationalities an opportunity to participate in church and community activities. In addition to Father Schellenberg, St. Columba Parish has had seven pastors. To date, Fr. Godfrey T. Mosley was the only pastor who was appointed as monsignor, in January 2001. Monsignor Mosley became vicar general for the Archdiocese of Washington and left the parish on March 16, 2001. Fr. Robert Buchmeier, from St. Nicholas Church, succeeded Fr. Michael J. King, who was transferred to Jesus the Good Shepherd Parish in Dunkirk, Maryland. (Courtesy of the St. Columba Parish collection.)

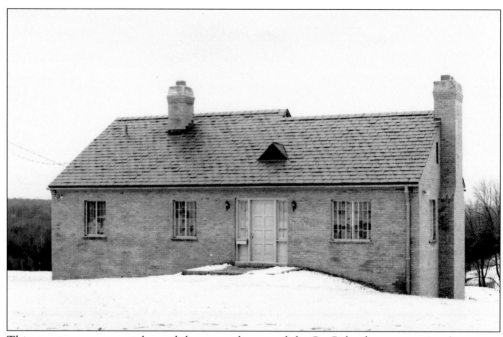

This structure, a convent, housed the nuns who served the St. Columba community. A convent is a community of priests, religious brothers or religious sisters, or the building used by the community, particularly in the Roman Catholic Church and, to a lesser degree, in the Anglican Communion. (Courtesy of the St. Columba Parish collection.)

In 1830, dedicated members living in the Oxon Hill area established St. Barnabas Church. The church, more than 140 years old, started out as a chapel of ease from St. John's Episcopal Church. The building is of plain architecture, small and low to the ground. Sparkling glazed headers were not built so they wouldn't catch the eye of parishioners. Many generations of the Baynes, Castles, Gerrads, Addisons, and Ashbys are buried in the cemetery. (Courtesy of the Carla Henry Rosenthal collection.)

In 1938, Rev. Robert F. Henry, his wife, Myrtle, and their daughter Sue answered a call from the King George's Parish. He then began his career as a reverend in Oxon Hill, Maryland. Their daughter Carla arrived later in the year and made the family complete. Over the years, Father Henry performed many tasks, including cleaning, restoring, ministering, and teaching. Father Henry and his family served St. Barnabas Church for 41 years. (Courtesy of the James E. Mills Jr. collection.)

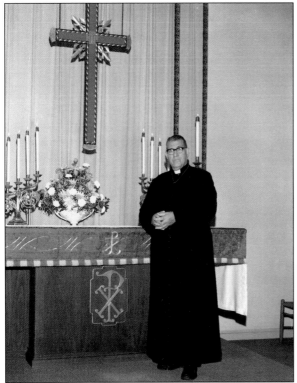

Rev. Robert F. Henry was born in Michigan and graduated in 1933 from Nastoah House College and Seminary. On September 21, 1934, he was ordained to the priesthood in Oak Park, Illinois, by Bishop George Craig Stewart. Father Henry ministered to both the St. John's–Broad Creek and St. Barnabas–Oxon Hill communities. For nine years, Father Henry was the only minister of any denomination in the area, and he served as pastor to people of all communions from Camp Springs to Piscataway to the District Line in Prince George's County. (Courtesy of the James E. Mills Jr. collection.)

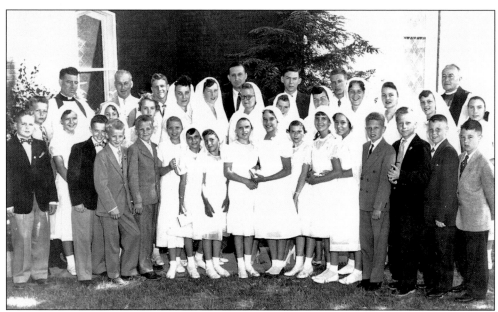

Fr. Robert F. Henry (left, third row) and his associate pastor stand outside St. Barnabas Church after performing a confirmation service for the youth of the congregation. Also included in this mix is the future husband of Sue Henry, James E. Mills Jr. The girls are all dressed in white with veils and the boys in their Sunday suits for this photograph commemorating this religious occasion. (Courtesy of the James E. Mills Jr. collection.)

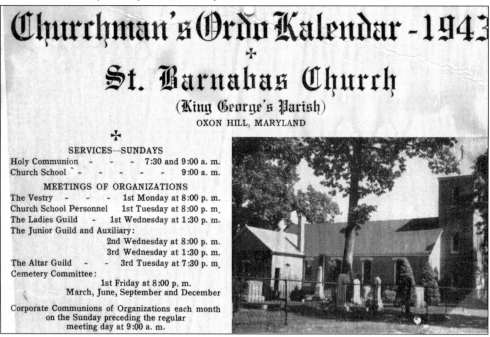

This is a 1943 St. Barnabas calendar outlining the Sunday services and meeting of organizations. The photograph shows the side view of St. Barnabas Church behind the cemetery. The large open field was used through the year for jousting tournaments, fairs, carnivals, ball games, and other forms of recreation. (Courtesy of the Carla Henry Rosenthal collection.)

The Jonah was a play presented by the King George Players at the St. Barnabas Parish Hall on Friday, May 14, 1926. The play was produced and directed by Ted Middleton. The talented congregation of St. Barnabas was very active in the community through outreach programs, which included programs such as this. (Courtesy of the Carla Henry Rosenthal collection.)

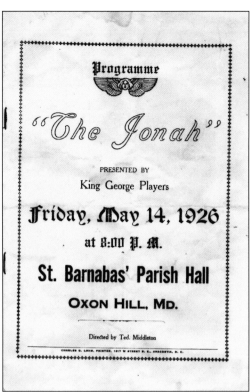

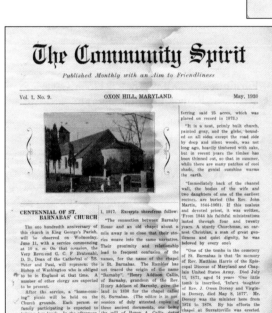

The 1930 issue of *Community Spirit* celebrates the 100-year anniversary of St. John's Episcopal Church, which is located in the Oxon Hill District. The publication was printed monthly and included articles on church and community activities, the Women's Auxiliary, Sunday school, weddings, and general information, as well as advertisements of the local businesses of the Oxon Hill district and the District of Columbia. (Courtesy of the Carla Henry Rosenthal collection.)

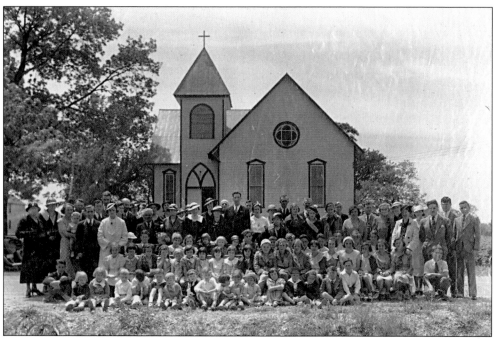

A typical post–World War II Sunday photograph shows the Oxon Hill United Methodist Church congregation sitting for a formal picture before the church building burned down. Members were dressed in their best clothing for this occasion. The church was originally established as a Methodist meetinghouse. (Courtesy of the Anna Talbert Mistretta collection.)

James C. Wood Printing, located on Nichols Avenue SE, was a family-owned business that provided printing services to many of the local businesses and churches in the Oxon Hill District and Washington, D.C. This advertisement was a part of the *Community Spirit*. The Wood family lived in the Oxon Hill area. (Courtesy of the Carla Henry Rosenthal collection.)

Five

OXON HILL MEMORIAL LIBRARY

The Oxon Hill Branch Library was built in 1966–1967 on the site of the original Sojourner Truth home and school. The library contains the African American Research Collection, which is housed in the Sojourner Truth Room. This comprehensive collection of reference materials on African American history and culture includes over 16,000 catalogue items. Vertical files contain pamphlets, clippings, and bibliographic materials. Copies of selected materials are also in the Oxon Hill Branch's circulating collection.

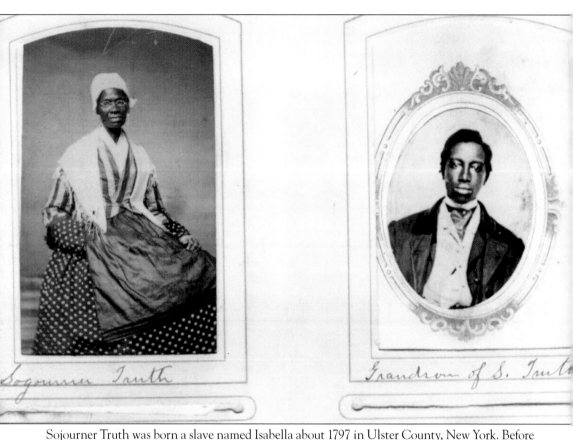

Sojourner Truth *Grandson of S. Truth*

Sojourner Truth was born a slave named Isabella about 1797 in Ulster County, New York. Before the age of 30, she had served three masters, married, and had five children. After obtaining her freedom in 1827, she did not want to carry anything from her life of slavery into her life as a free woman, and so she changed her name from Isabella to Sojourner Truth because she was going to travel the country carrying truth to the people. (Courtesy of http://www.kyphilom. com/www/gif/struth1.jpg.)

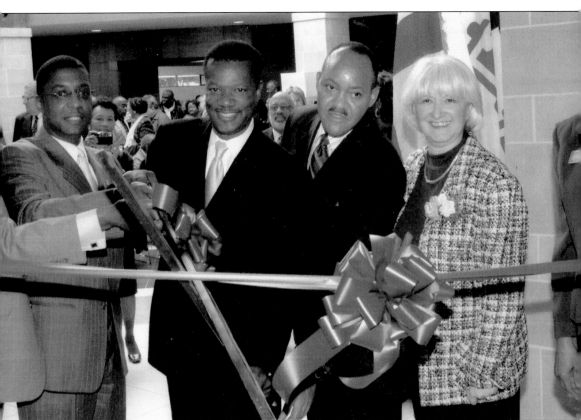

The Oxon Hill Branch of the Prince George's County Memorial Library was closed for more than three years for remodeling. The library was shut down to make more space for the African American Research Collection in the Sojourner Truth Room. In June 2005, the library reopened for business. In October 2005, the library was rededicated after extensive renovations. From left to right, county councilmember Tony Knotts (D–District 8), county executive Jack Johnson, board of trustees president Kevin Rattliff, library director Micki Freeny, and other officials gather for a rededication ribbon-cutting ceremony. (Courtesy of the Prince George's County Executive's Office, Communications Department.)

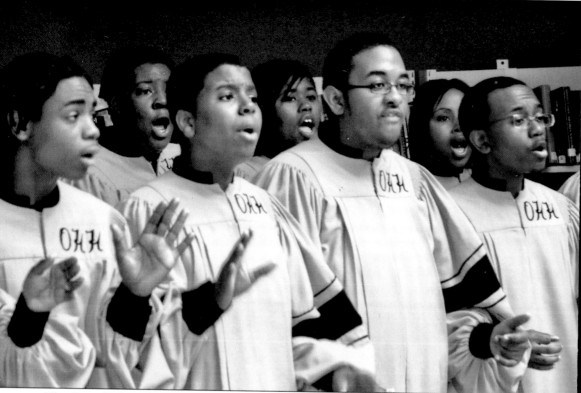

The Oxon Hill High School Choir entertained the audience at the rededication of the Oxon Hill Memorial Library. Oxon Hill High School is a comprehensive high school with a science and technology center serving the students of southern Prince George's County. The choral group sings for special events in their school as well as the community. (Courtesy of the Prince George's County Executive's Office, Communications Department.)

Six

PEOPLE, PLACES, AND NEIGHBORHOODS

Oxon Hill for the longest time was made up of rural areas and working farms. Major emphasis has largely been on residential development with 8 to 16.9 units per acre, mostly townhouses or apartment condominiums. Oxon Hill is considered a bedroom community with a constant and steady growth of residential dwellings, several strip malls, and scattered commercial buildings such as the Lucente Building and the Constellation Center, which are located at busy intersections such as Livingston, Wheeler, St. Barnabas, and Oxon Hill Roads. The building of the Wilson Bridge and South Capital Street Bridge has made the Oxon Hill District more desirable and accessible via public transportation and private cars. Subdivision communities within the Oxon Hill District include but are not limited to Barnaby Manor, Birchwood City, Bock Terrace, Brinkley Manor, Brooke Manor, Careybrooke, Cedar Ridge, Deer Park Heights, Forest Heights, Fort Foote, Fort Foote Village, Glassmanor, Hough Park, Kerby Hills, Livingston Oaks, Livingston Park, Murray Hills, Owens Road, Oxon Hill, Potomac Vista, River Bent, River Ridge, Southlawn, Temple Hills, and Treasure Cove.

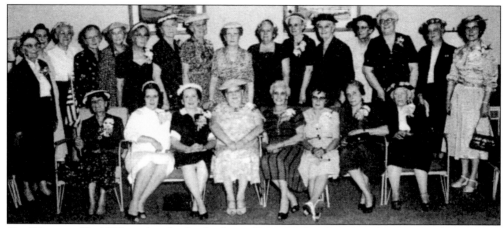

On February 22, 1929, under the leadership of Mrs. Walter Brooke, the Oxon Hill Women's Community Club organized at the Oxon Hill High School. The history of the club, a rural and a federated club, has a record of local community service along educational and public lines. The library of the Consolidated School was started by the club. Newly installed officers are shown above in 1930. They are, from left to right, (seated) Mrs. Leo Langley; Mrs. Arthur Cribbs, treasurer; Mrs. William Bowie, president of the Prince George's County Federation of Women's Clubs; Mrs. Martin L. Shaw, president; Mrs. Louise Finagin, vice president; Mrs. William P. Dalton, secretary; Mrs. Robert Meredith, director; and Katie Grimes, corresponding secretary; (standing) Mrs. Mary Cochran, Mrs. John Stratman, Mrs. Olive Maines, Mrs. Arno Viehoever, Mrs. William Breen, Mrs. William Cohen, Mrs. Howard Grimes, Mrs. Edgar Thorne, Mrs. William E. Miller, Mrs. Norman Stamp, Mrs. R. H. J. Campbell, Mrs. William Stanbach, Mrs. Frank Underwood, Mrs. George Hanson, Mrs. Trainor, and Mrs. Nair. (Courtesy of the Prince George's County Memorial Library, Oxon Hill Branch collection.)

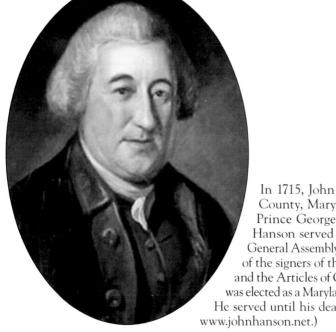

In 1715, John Hanson was born in Charles County, Maryland, and died in Oxen Hills, Prince George's County. From 1757 to 1781, Hanson served as a member of the Maryland General Assembly House of Delegates. He was one of the signers of the Declaration of Independence and the Articles of Confederation. In 1780, Hanson was elected as a Maryland delegate to the U.S. Congress. He served until his death in 1783. (Courtesy of http:// www.johnhanson.net.)

The John Hanson historical plaque on Oxon Hill Road marks the area where John Hanson died on November 15, 1783. Hanson was visiting his nephew at Oxon Hill Manor at the time of his death. A marker was dedicated on October 1967 to him, the first president of the United States under the Articles of Confederation. The marker was presented by Herbert W. Reichelt, president of the Prince George's County Commission, and William N. Morrell, executive secretary of the John Hanson Society of Maryland. (Courtesy of the Martin Luther King Jr. Library, Washingtoniana Collection.)

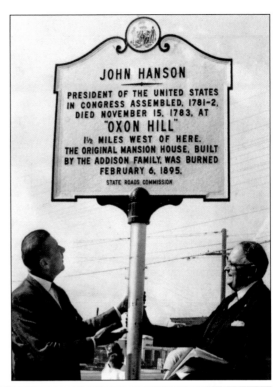

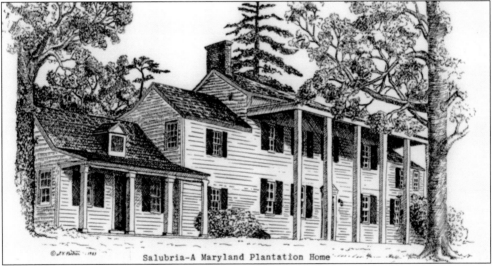

Salubria-A Maryland Plantation Home

John H. Bayne was a noted doctor, horticulturalist, and member of the Maryland General Assembly House of Delegates. Dr. Bayne built a picturesque home at the end of a tree-lined driveway on Oxon Hill Road. In 1827, Dr. Bayne built his home, called Salubria. He used the home as an office and sometimes a hospital. Dr. Bayne later moved the practice to Capitol Hill. His patients included Pres. William McKinley. Dr. Bayne served 20 years as the director of the Catholic Providence Hospital in Washington, D.C. He was very good friends with Charles B. Calvert, and together they were instrumental in planning the College of Agriculture, later to become the University of Maryland. Dr. John Bayne's son, J. Breckenridge Bayne, also became a doctor and continued his father's interest in politics and medicine. (Courtesy of the James E. Mills Jr. collection.)

Sue V. Mills (1923–2005) was a former Prince George's County council member and chair of the Prince George's County School Board. She was born in Streator, Illinois, but was educated in Prince George's County schools, graduating from Oxon Hill High School and the University of Maryland. Mills's political career started out with her volunteering with the Oxon Hill Democratic Club and working as a clerk of the county's elections office in the 1970s. Mills, a community activist, served on the council's Health, Education, and Human Service and Housing, Transportation, and Environment Committees. She was a well-known orator and was considered to be flamboyant, but she was dedicated to her constituents. (Courtesy of the James E. Mills Jr. collection.)

In 1980, Sue V. Mills became the first female member of the Home Plate Club. In 1984, Sue, an avid baseball fan, was appointed by D.C. mayor Marion Barry to the D.C. Baseball Commission. Sue's civic contribution included membership in the Southeast Business and Professional Women's Club and Accokeek Volunteer Fire Department and the board of trustees of St. Mary's Ryken, a Catholic preparatory school. (Courtesy of the James E. Mills Jr. collection.)

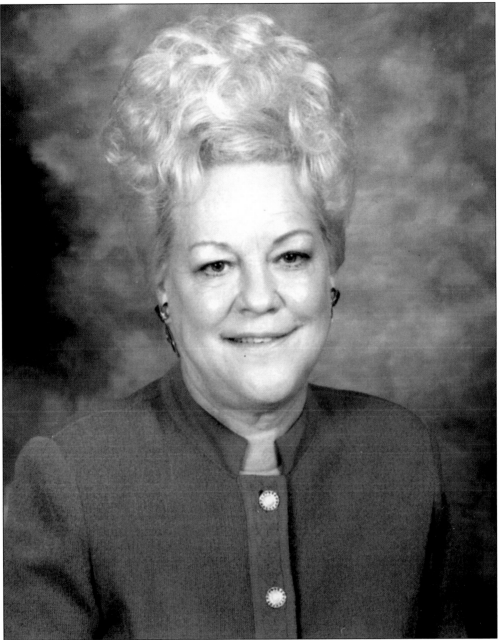

Sue V. Mills served four terms on the Prince George's County Council. She was elected at-large in 1978 and re-elected to represent Councilmanic District 8 in 1982, 1986, and 1990–1995. Sue was very passionate about her love of Oxon Hill and worked as an officer or chairwoman of the Oxon Hill Democratic Club, Southern Maryland Heart Association, and Oxon Hill Boys and Girls Club. (Courtesy of the James Mills Jr. collection.)

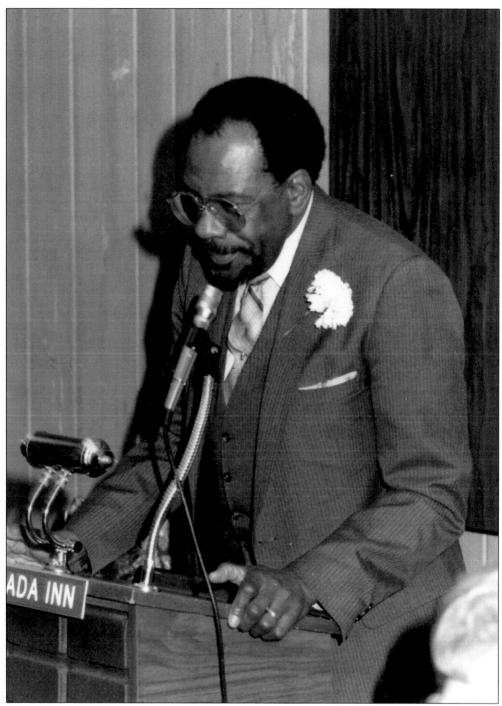

Although born in Atlanta, George Otis Ducker was raised in New Orleans, Louisiana. In the mid-1950s, he moved to Prince George's County after serving in the U.S. Army Band at Fort Belvoir, Virginia. As a community activist and local politician, Ducker was one of the founders of the Coalition on Black Affairs (COBA) in Southern Maryland with Albert Barrett, Christine and Robert Jones, and Roger Davis. (Courtesy of the Otis Ducker collection.)

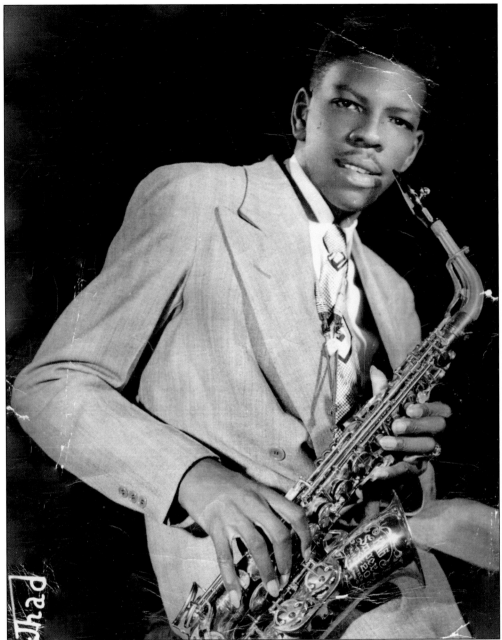

As a teenager in New Orleans, Otis Ducker began taking saxophone lessons, and he continued his music experience at a small college in Alabama. Ducker carried the responsibility of supporting his family after the death of his father. His affiliation with the musicians' union New Orleans Local 496 encouraged him to become an accomplished musician. Mr. Ducker taught music in his spare time. He plays the saxophone, oboe, clarinet, and other reed instruments. (Courtesy of the Otis Ducker collection.)

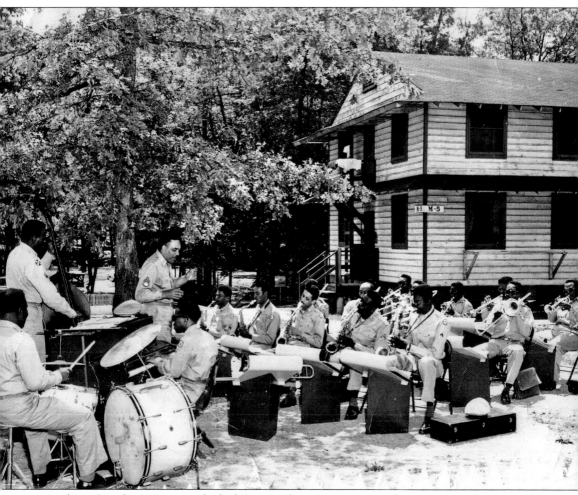

In the 1950s, the U.S. Army drafted Otis Ducker. He was assigned to a construction engineer battalion in the Washington, D.C., area. Because of his musical talents, he transferred to the 75th Army Band, where he spent the next three years. After his discharge from the army, he decided to settle down in the metro area. Ducker worked for the federal government, played music part-time, and served as a music administrator for the Washington, D.C., Local 710 union branch. (Courtesy of the Otis Ducker collection.)

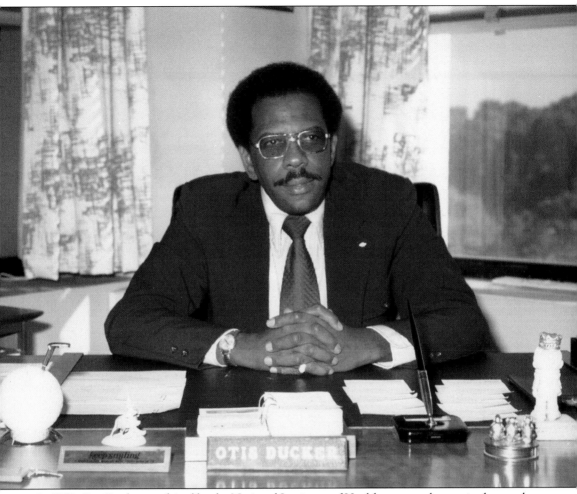

In 1953, Otis Ducker was hired by the National Institutes of Health as a storekeeper in the supply unit of the Supply Management Branch. After serving in a variety of positions, Ducker was named chief of the branch in 1969. Three years later, he was appointed assistant director for Material Management, a post he held until he was named director of the Division of Administrative Services. (Courtesy of the Otis Ducker collection.)

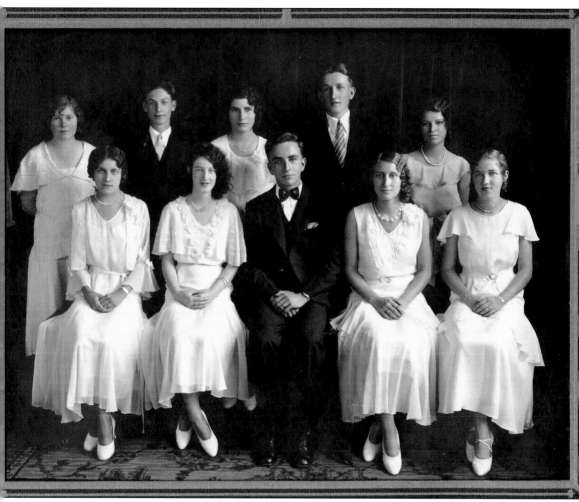

In 1925, the Oxon Hill High School began as a union of five elementary schools with 2 to 3 teachers. At that time, it was called the Oxon Hill Consolidated School. The 1931 graduating class of the Oxon Hill High School are, pictured here not in order, Doris Taylor, John McIntosh, Irma Taylor, Anna Talbert, Sara Cox, Pearl Mattingly, Robert Phelps, Angela Wisthal, Grover Kirby, and Margaret Lusby. (Courtesy of the Anna Talbert Mistretta collection.)

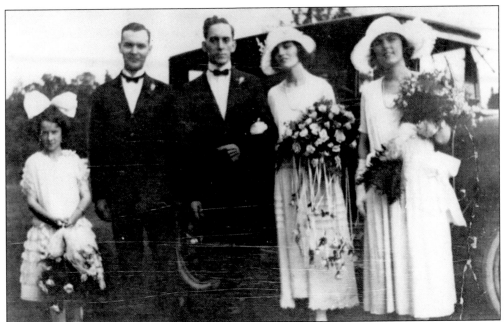

On August 11, 1923, Roy Clark and Edith Cohen married in Oxon Hill. From left to right are Anna Talbert, Roy's cousin and flower girl; Ralph Clark, brother of the groom; Roy Clark, the groom; Edith Cohen, the bride; and Amy Cohen, sister of the bride and maid of honor. A large portion of the Clark family farm is now known as Indian Head Highway. (Courtesy of the Anna Talbert Mistretta collection.)

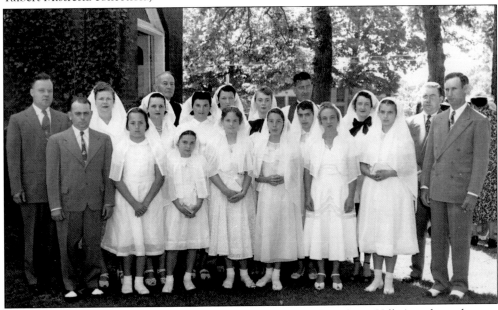

This is the confirmation class at St. Barnabas Episcopal Church in Oxon Hill. At right in the rear, Mrs. Anna Talbert Mistretta (with black bow) is standing to the right of Fr. Robert Henry (father of Sue V. Mills). Mrs. Mistretta was a member of St. Barnabas Church choir. Father Dwan is also shown in this photograph. Mrs. Mistretta was employed by Woodward and Lothrop Department Store at the time. (Courtesy of the Anna Talbert Mistretta collection.)

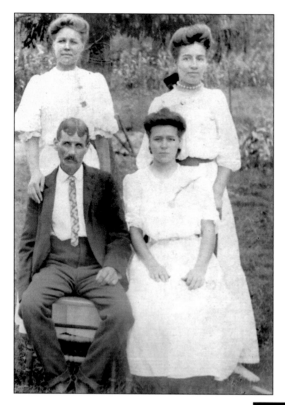

Tony Allen (seated, left), Mary (seated, right), Ellen (standing, left), and Grandma Sallie Talbert (standing, right) sit on the family farm. The Talbert dairy farm was initially a part of the original Addison parcel in the Oxon Hill District. Dr. John H. Bayne was a neighbor of the Talberts. (Courtesy of the Anna Talbert Mistretta collection.)

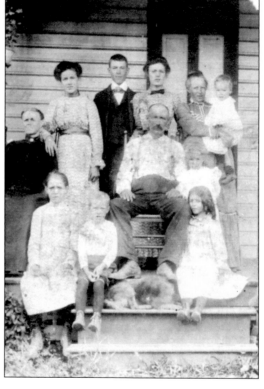

A family photograph shows, from left to right in back, Virginia Hill, Anna Mistretta's grandmother; Sallie Hill, Anna's mother; unidentified; Mabel Hill; and Ellen Hill. Seated on the steps is William Hill, Anna's grandfather. The five children are unidentified. The family generally spent quality time sitting on the front porch of the family home in Oxon Hill. The home was on a parcel located directly across the road from the Salubria Mansion of the Dr. John H. Bayne family. There are three generations of Hills in this photograph. (Courtesy of the Anna Talbert Mistretta collection.)

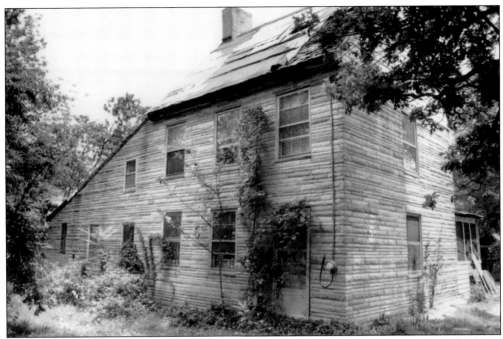

Butler House is located on Oxon Hill Road. This two-story home with a one-story shed-roof kitchen attached and a modern-form stone veneer was built by Henry A. Butler and served as a house and post office. Since 1853, the house has been the home of the Butler family, a free black family that came from Charles County. (Courtesy of the Maryland–National Capital Park and Planning Commission History Division.)

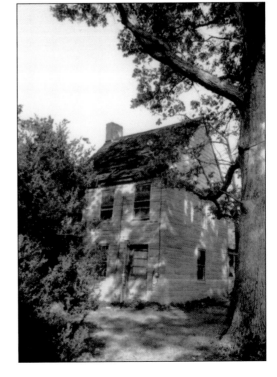

The Butler family dwelling was the nucleus of the farm that the family developed around it, including a chicken house, a meat house, barns, and other necessary domestic and agricultural outbuildings. In 1873, the house was legally deeded to Henry Alexander Butler and is still in the possession of the family. (Courtesy of the Maryland–National Capital Park and Planning Commission History Division.)

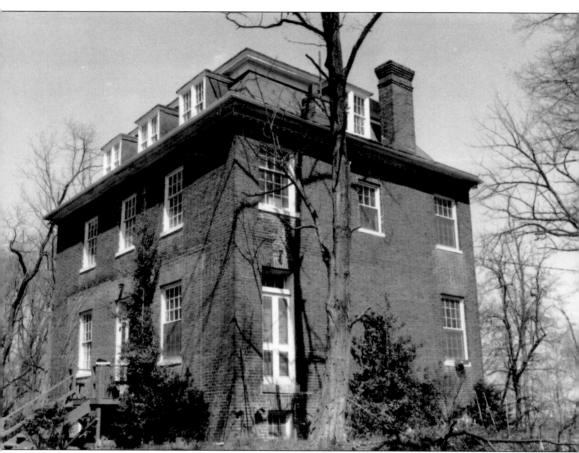

Admirathoria (Upper Notley Hall), a two-and-a-half-story late-Georgian brick house with asymmetrical floor plan and a mansard roof, was originally situated on 246 acres. Notley Hall was named after the son of Francis Rozier and remained family property for six generations. (Courtesy of the Maryland–National Capital Park and Planning Commission History Division.)

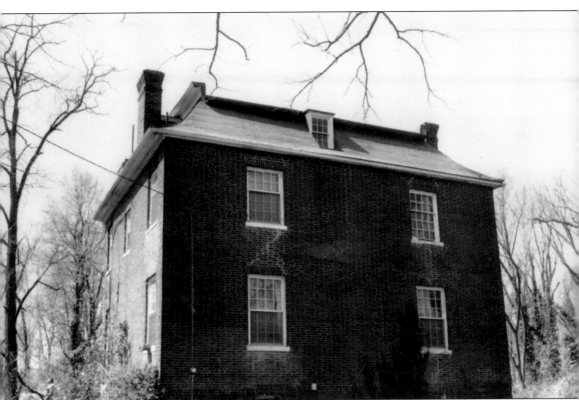

Admirathoria is a significant Georgian structure and a unique example of Colonial homes in Prince George's County. This magnificent house is located on Clay Drive in Oxon Hill. The house was built in the 18th century, altered in the 1870s, and is in serious decay from neglect and abandonment. (Courtesy of the Maryland–National Capital Park and Planning Commission History Department.)

Repetti-Washington House is a two-story gable-roofed structure with an L-shaped plan, a gable-seamed metal roof, asbestos shingle siding, a boxed cornice with crown molding, overhanging eaves, and pronounced cornice returns in the gable ends. It was built after 1891 by Mary E. Repetti and is located on Wheeler Road. Repetti-Washington House originally stood on a 21-acre farm. (Courtesy of the Maryland–National Capital Park and Planning Commission History Department.)

The Repetti-Washington House is on a small lot just south of a gas station in a heavily developed area near the southeast border of Washington, D.C. The property was subdivided into smaller lots by Seraphin Schreiber after 1901. The house is an example of late-19th-century vernacular architecture with a Greek Revival cornice and Victorian porch posts and brackets. It is one of the few remaining evidences of a formerly rural nature in an area of subdivisions and commercial development. (Courtesy of the Maryland–National Capital Park and Planning Commission History Department.)

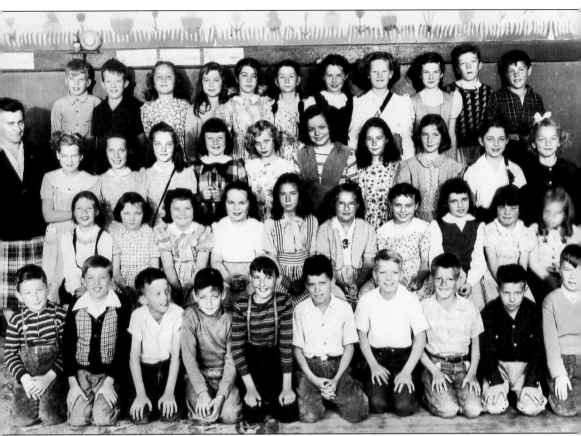

This is the fourth-grade class photograph of Carla Henry (middle, second row) and her unidentified classmates at the Oxon Hill Elementary School. Her teacher was Miss Darlington, who taught the pupils their arithmetic, civics, vocabulary, and other subjects. This picture was taken on May 25, 1948, and Carla was nine and a half years old. (Courtesy of the Carla Henry Rosenthal collection.)

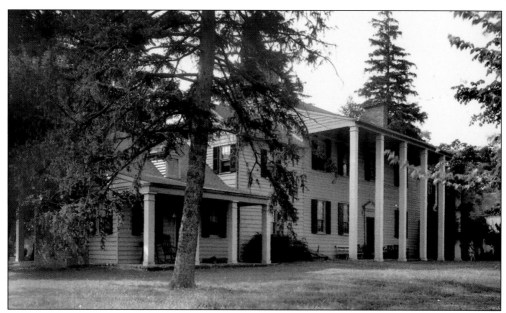

Salubria was located across the street from the Oxon Hill Manor on Oxon Hill Road. Slightly to the north was the plantation home of the Bayne family. Ellsworth Bayne originally purchased 328 acres from Rev. Walter Dulany Addison and gave 64 acres to his son, Dr. John H. Bayne, as a wedding present. In 1827, Dr. and Mrs. John H. Bayne built Salubria as a two-and-a-half-story frame house with flanking kitchen wing and doctor's office. (Courtesy of the Maryland–National Capital Park and Planning Commission History Department.)

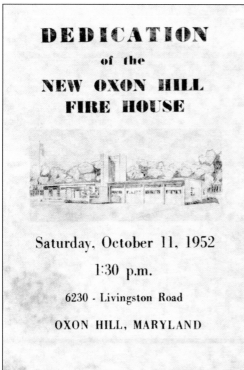

On Saturday, October 11, 1952, there was an opening and dedication of the new Oxon Hill Firehouse at 6211 Livingston Road. In 1972, Mrs. Sallie Talbert donated the family farmhouse to the fire department for the training of firefighters. Mrs. Anna Mistretta's brothers, Edward and Herbert Talbert, served as fire chiefs at this firehouse. (Courtesy of the Anna Talbert Mistretta collection.)

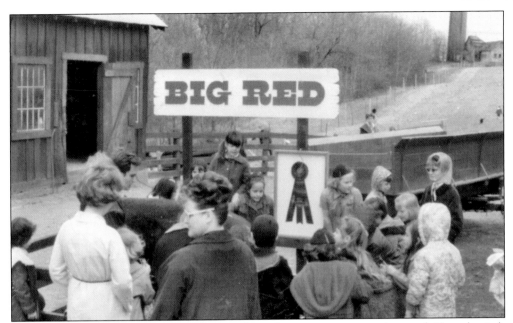

Big Red is the large red barn where harvest from the previous summer is stored. Corn (maize), wheat, and sorghum are grown at Oxon Hill Farm. Other grains grown at Oxon Hill Farm are rice, barley, oats, rye, and millet. Bales of hay, a dried forage crop used as animal feed, especially in wintertime, are stored in the hay barn. Straw, the stalk of grain plants, is used for animal bedding. (Courtesy of the National Park Service.)

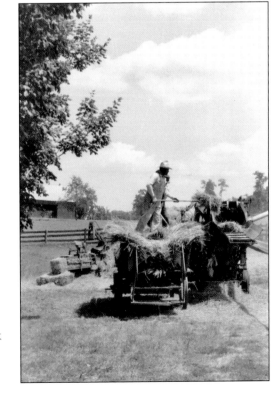

In 1967, Godding Croft, St. Elizabeth's largest working farm, was established year-round as the Oxon Hill Cove Children's Farm. The farm was designed to teach children about 19th-century farming, cultivated crops, livestock, and agricultural tools. A farmer shows how to use a pitchfork in collecting wheat for the thresher. (Courtesy of the Martin Luther King Jr. Library, Washingtoniana Collection.)

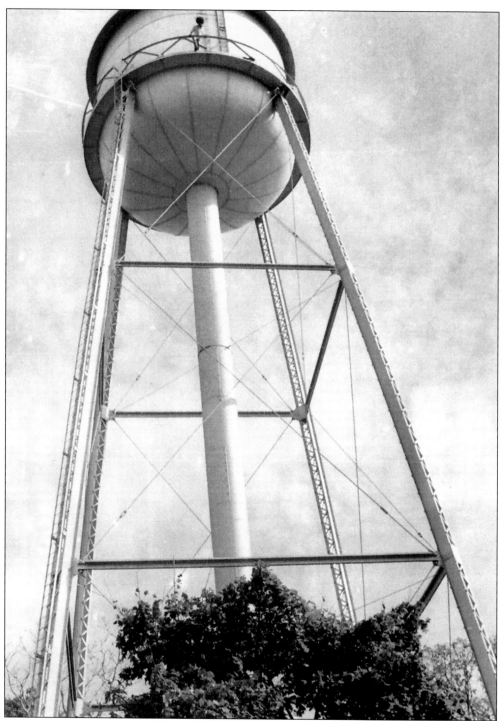

The St. Elizabeth Hospital water tower, built in the 1930s, is set into the hillside above the ravine northeast of the Mount Welby house. Roger Moore, age 21, a resident of Oxon Hill, is standing on the top of the tower looking over the St. Elizabeth grounds. (Courtesy of the Martin Luther King Jr. Library, Washingtoniana Collection.)

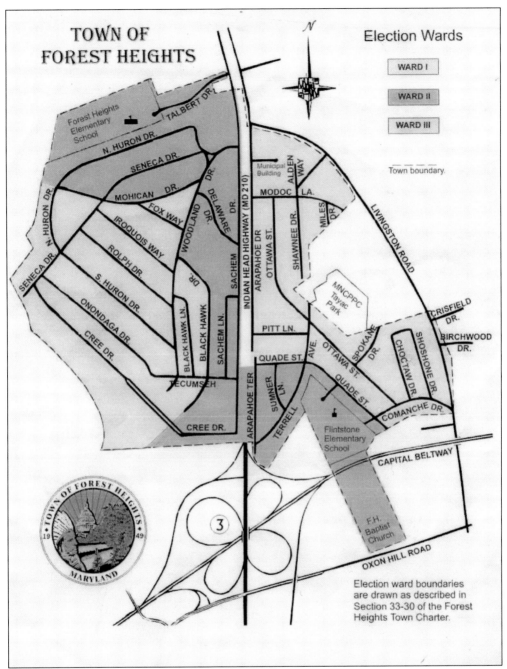

The land for the Forest Heights community was one of the first parcels sold by the George Herbert Talbert family in Oxon Hill to Southern Maryland Homes. Forest Heights was first established as a subdivision. In 1949, it was incorporated as a town; they created and distributed their first community newsletter in July 1951 to keep the residents updated on the town's activities. (Courtesy of http://www.forestheights.biz.)

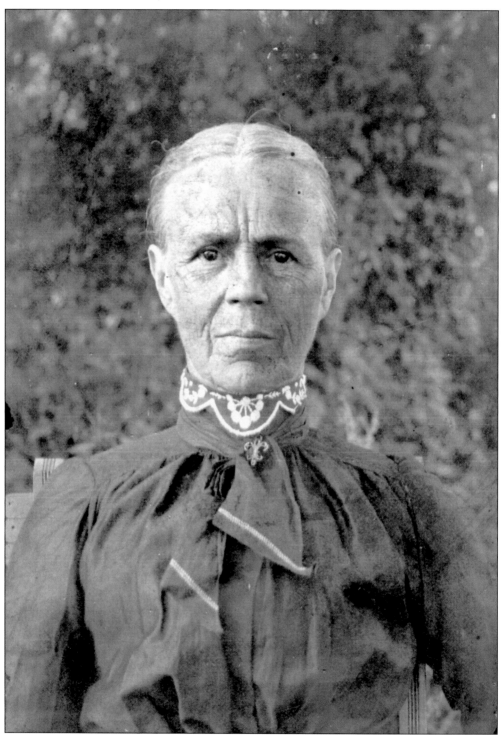

Virginia Hutchinson Clubb is the maternal great-grandmother of Anna Talbert Mistretta. Mrs. Clubb was brought up on a diary farm in the Oxon Hill area of Prince George's County. (Courtesy of the Anna Talbert Mistretta collection.)

This is the funeral card of Mrs. Frances Ann Elizabeth (Clubb) Hill (1865–1917), who was a housewife and mother of six daughters and six sons. She lived out her life in the Oxon Hill District. Mrs. Hill, Anna Mistretta's grandmother, is buried in the Christ Episcopal Church cemetery in Surrattsville, Maryland. (Courtesy of the Anna Talbert Mistretta collection.)

In loving remembrance of

France Ann Elizabeth Hill

who entered into eternal rest

June Second, Nineteen hundred and seventeen

Age 51 years, 9 months and 24 days

Once our home was bright and happy,
And, oh, how sad it is today,
Since our darling Mother
Has forever passed away.

Though cast down, we are not forsaken,
Though afflicted not alone;
Thou didst give and thou hast taken,
Blessed Lord, Thy will be done.

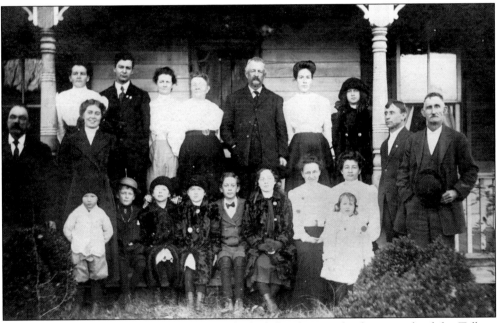

This is a gathering of the Hill, Talbert, and Clark families on the front porch of the Talbert family farm in Oxon Hill. The photograph includes, from left to right, (first row) Edward Talbert, Egbert Clark, ? Green, Ethel Payne, Roy Clark, Edith Payne, Ruth Payne, and Mary Green with daughter Evelyn; (second row) Sam Anderson, Ester England, Louis Green, and Charlie Cox; (third row) Maud England, Ralph Clark, Gerry Clark, Anna Elizabeth Talbert (Cissel), George Herbert Talbert, Sallie Talbert (pregnant with Anna), and Eva Clark. (Courtesy of the Anna Talbert Mistretta collection.)

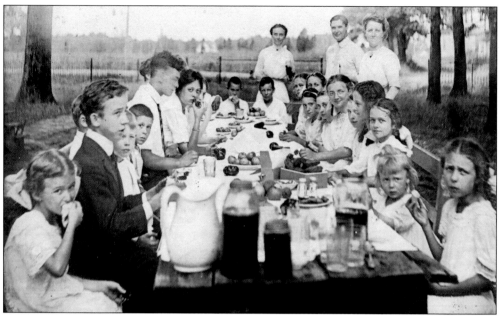

This photograph depicts a typical 1920s after-church Sunday dinner with the blended families of the children and grandchildren of Frances Ann Clubb and Edward Hill sitting at the table. The Clubb, Hill, Talbert, Payne, and Grimes families would gather together each Sunday, enjoying cool drinks and smiling for the photographer. (Courtesy of the Anna Talbert Mistretta collection.)

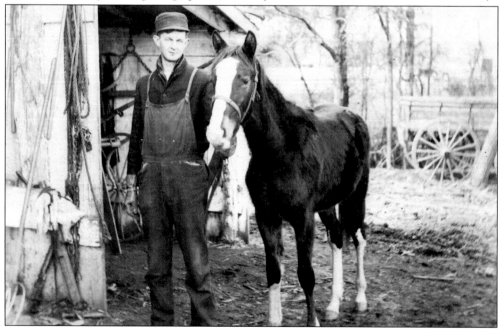

Jonathan Perkins Talbert and his beloved horse Daisy pose for this photograph. The property was located along what is now known as Indian Head Highway. In 1941, Talbert sold a parcel of land to Southern Maryland Homes, a developer that built the Forest Heights subdivision, which later became the town of Forest Heights. A street is dedicated to the Talbert family. (Courtesy of the Anna Talbert Mistretta collection.)

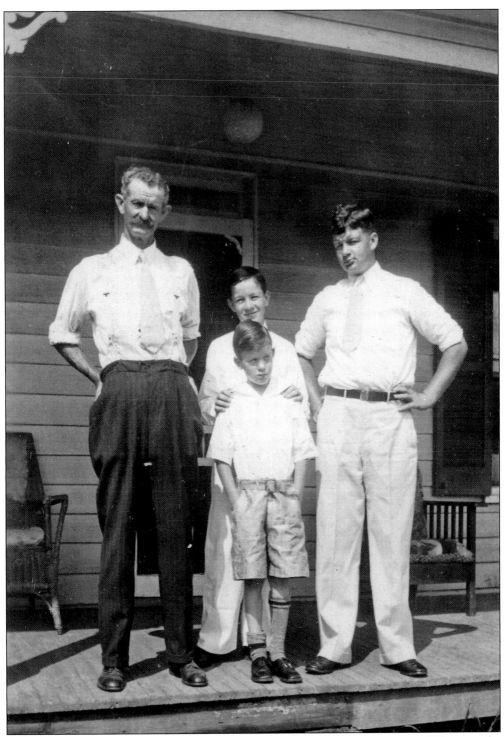

From left to right, J. Perkins Talbert stands with his sons Dempsey, Lawrence, and Elmer on the front porch of the house. Anna Mistretta remembers that her grandfather, J. Perkins, enjoyed quiet Sunday afternoons on the porch. (Courtesy of the Anna Talbert Mistretta collection.)

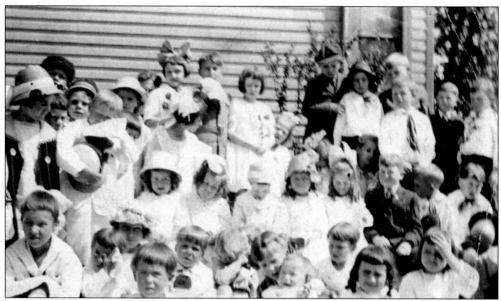

Sallie Hill Talbert sits with her Sunday school class at Oxon Hill Methodist Church. Sallie was a very strong and devoted woman who attended church every Sunday regardless of the weather. Sallie is sitting in the middle with her head looking down. (Courtesy of the Anna Talbert Mistretta collection.)

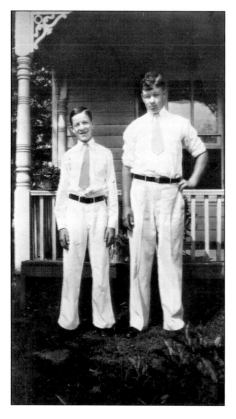

Lawrence (left) and Dempsey Talbert pose for the photographer in their Sunday-best white long trousers. (Courtesy of the Anna Talbert Mistretta collection.)

A 19th-century photograph of mother Frances Elizabeth Clubb and son Norm Hill shows them leisurely sitting under a tree on the family's dairy farm in Suitland, Maryland, enjoying the cool breezes of a summer day. (Courtesy of the Anna Talbert Mistretta collection.).

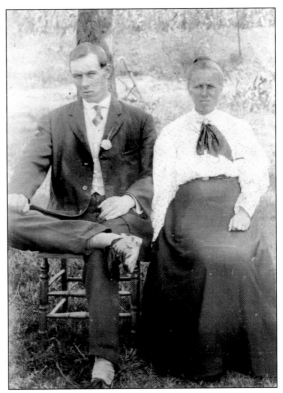

Sallie Hill Talbert's brothers, Johnnie (left) and Norman Hill, enjoyed taking time out to pose for this picture. (Courtesy of the Anna Talbert Mistretta collection.)

Dempsey Talbert, uncle of Anna Talbert Mistretta, poses in front of a car in his roadster's best clothing. Young Dempsey is ready to take to the road in style with goggles. (Courtesy of the Anna Talbert Mistretta collection.)

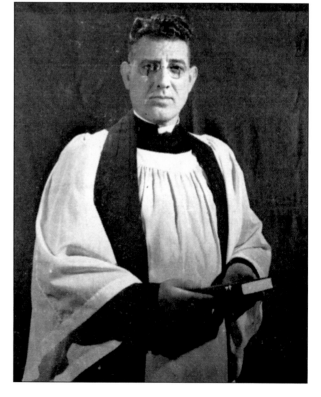

This is a formal photograph of Fr. Robert Henry, pastor of St. Barnabas Episcopal Church. He served for more than 40 years at both St. Johns and St. Barnabas. During World War II, Father Henry also served as the Episcopal chaplain for nearby Fort Washington. Under his guidance, the church became the powerhouse of the community. (Courtesy of the Anna Talbert Mistretta collection.)

Young Annie Elizabeth (Cissel) Talbert, grandmother of Anna Mistretta, poses for this formal picture. The photograph was taken by Farber Photographers in Washington, D.C. (Courtesy of the Anna Talbert Mistretta collection.)

The photograph depicts Anna Mistretta's grandparents, Annie Elizabeth (Cissel) and Jonathan Perkins Talbert, sitting on the porch of their home in their Sunday best. The home was a traditional clapboard house. (Courtesy of the Anna Talbert Mistretta collection.)

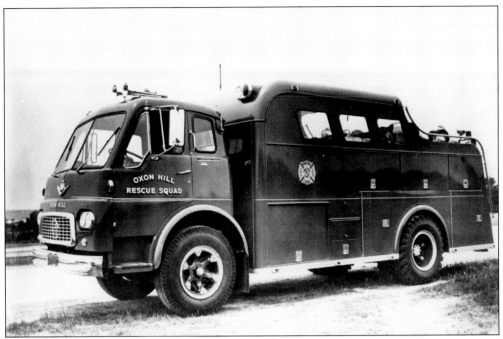

In 1951, the Oxon Hill Fire Volunteer and Rescue Squad purchased a GMC Engine 350-gallon-per-minute fire truck. The new truck replaced the REO fire truck with Buffalo equipment. (Courtesy of the Phyllis and Arthur Cox collection.)

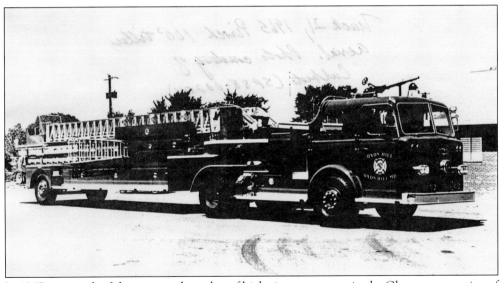

In 1965, as a result of the increased number of high-rise apartments in the Glassmanor section of the Oxon Hill District on Livingston Road, a 100-foot aerial ladder truck was purchased for the Oxon Hill Volunteer Fire and Rescue Squad. Truck 21 was a 1965 Pirsch 100-foot tiller aerial. (Courtesy of the Phyllis and Arthur Cox collection.)

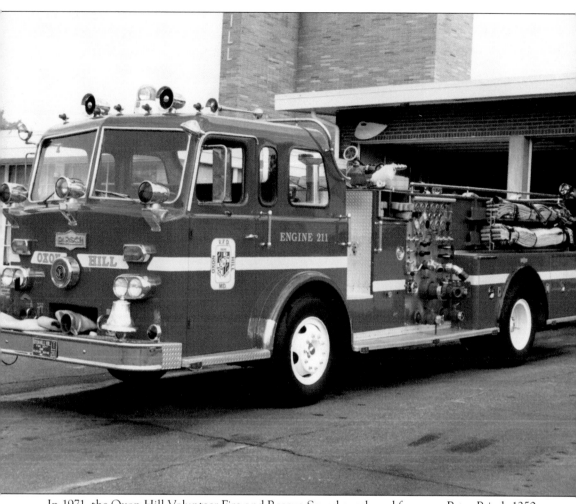

In 1971, the Oxon Hill Volunteer Fire and Rescue Squad purchased four new Peter Prisch 1250-gallon-per-minute, 300-gallon-tank fire trucks. On October 17, 1980, Engine 211 was photographed at Station 21. (Courtesy of the Phyllis and Arthur Cox collection.)

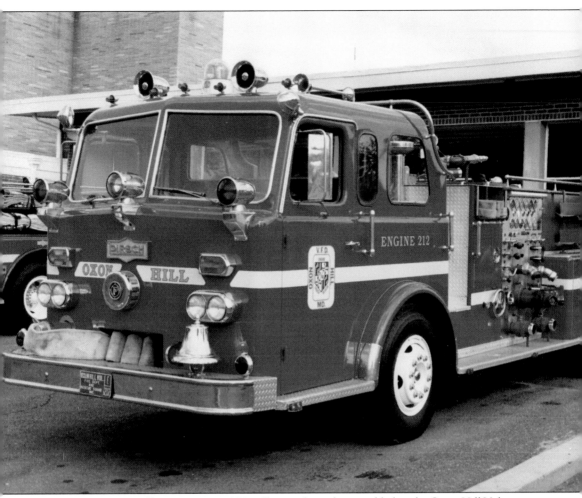

Engine 212, a 1250-gallon-per-minute, 300-gallon-tank truck, was added to the Oxon Hill Volunteer Fire and Rescue Squad. (Courtesy of the Phyllis and Arthur Cox collection.)

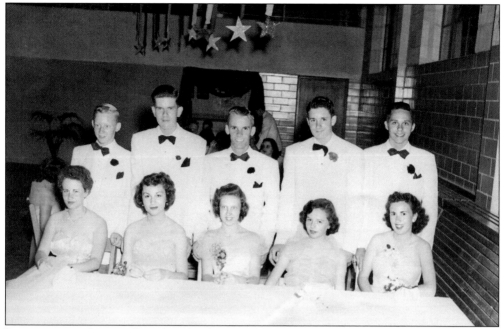

Junior prom at Oxon Hill High School was held in the school's gymnasium and decorated by the prom committee in school colors. The school band played the popular tunes of the day, and the students had a wonderful time dancing the night away. (Courtesy of the Phyllis and Arthur Cox collection.)

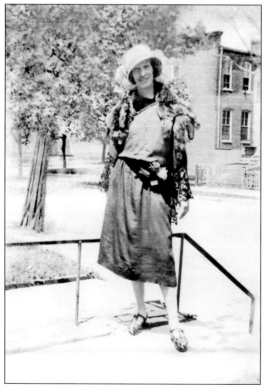

Mabel Estelle Hill Cox, mother of Arthur Cox, stands in front of the family home in her best Sunday outfit in Birchwood City. Mabel married Augustus Cox in September 1923. (Courtesy of the Phyllis and Arthur Cox collection.)

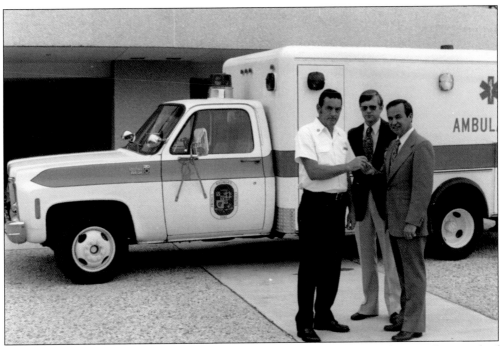

In 1978, county executive Winfield Kelly (right) and M. H. Estepp (center) give volunteer chief Maddox (Oxon Hill Volunteer Fire and Rescue Squad, Company 21) keys to the first of 16 new county ambulances being integrated into service. (Courtesy of the Phyllis and Arthur Cox collection.)

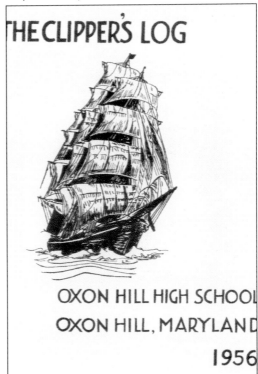

THE CLIPPER'S LOG

OXON HILL HIGH SCHOOL
OXON HILL, MARYLAND
1956

This is the cover of the 1956 *Clipper's Log*, the Oxon Hill High School yearbook. Carla Henry was a senior enjoying high jinks as a teenager, going to sock hops, hanging out at the Hot Shoppe for pop and burgers, and enjoying the movies. (Courtesy of the Carla Henry Rosenthal collection.)

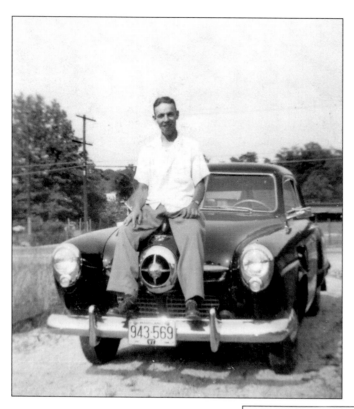

In this 1950 photograph, Augustus Cox, father of Arthur and Bernard, sits on the hood of a 1935 Studebaker. The Studebaker seemed to be a favorite of the Cox family. (Courtesy of the Phyllis and Arthur Cox collection.)

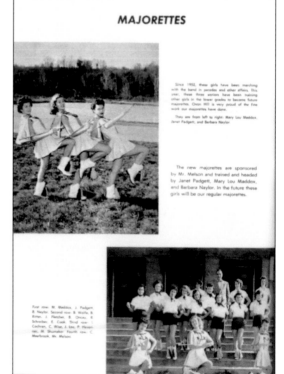

This is a photograph from the 1956 Oxon Hill *Clipper's Log* that shows the Oxon Hill High School majorettes. From left to right in the top image are Mary Lou Maddox, Janet Padgett, and Barbara Naylor showing their school spirit and color. Since 1952, the girls have been marching with the band in parades and other affairs. These three teenagers have trained girls in other grades to be future majorettes. They cheered for the marching band. (Courtesy of the Carla Henry Rosenthal collection.)

In 1947, Carla Henry took her official school photograph at Oxon Hill Elementary School. She is wearing a plaid dress with a white Peter Pan collar and a matching hair ribbon. Carla had just entered fourth grade and was joined by her best friends, Ella, Emma, and Flossy, for a year of reading, writing, and arithmetic. (Courtesy of the Carla Henry Rosenthal collection.)

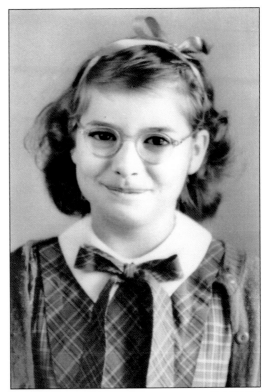

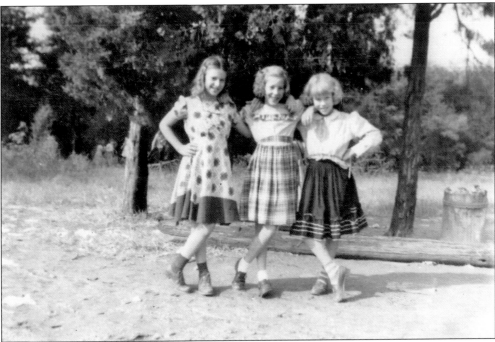

On a spring day in 1948, Carla Henry took her Kodak Brownie camera to school to take pictures of, from left to right, her best friends, Ellen, Emma, and Flossy, during recess. (Courtesy of the Carla Henry Rosenthal collection.)

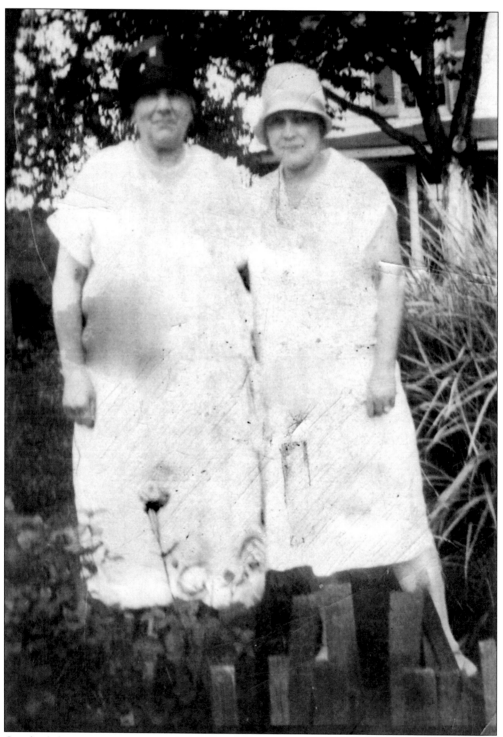

On the left is Mary Hill with Ethel Owens Cox at Ellen Ann Dean Cox's house on the hill, now Birchwood City. The two ladies not only were related but were very good friends. Mary Hill married a Revell, then a Grimes. (Courtesy of the Phyllis and Arthur Cox collection.)

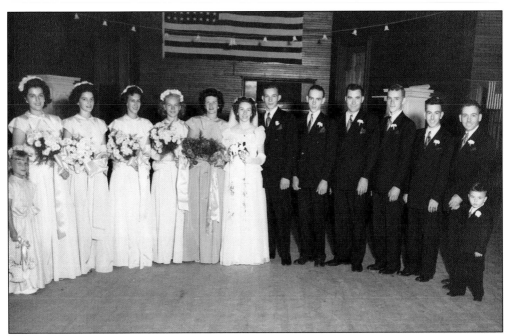

On October 8, 1949, Bernard Cox joined hands in matrimony with Theresa Thorne. Present from left to right are Gussie Cox, Betty Williams, Barbara Williams, Agnes Ryan, Pat Cox, Adele Thorne Bowman, Arthur Cox, William Bowman, Joseph (Joe) Cox, Lawrence Thorne, George Thorne, and an unidentified nephew of Bernard Cox. (Courtesy of the Phyllis and Arthur Cox collection.)

Russell Grimes, born c. 1888 and died c. 1973, stands on the steps of the old Grimes house some time before 1966. Grimes was the husband of Mary Rachel Hill Revell Grimes and the uncle of Arthur Cox. His home was known to the neighbors as a zoo because he raised many animals. (Courtesy of the Phyllis and Arthur Cox collection.)

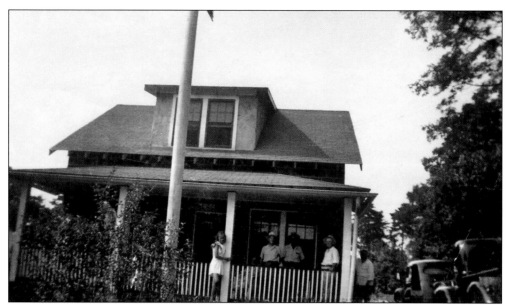

In 1940, Arthur Cox built the above house. Arthur and Phyllis Cox moved into their home on August 1, 1940. They lived there until they moved to their house in Southlawn in Oxon Hill. (Courtesy of the Phyllis and Arthur Cox collection.)

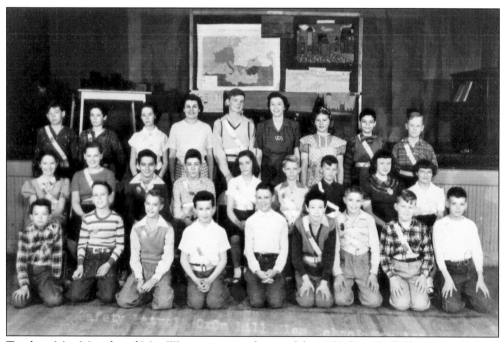

Teachers Mrs. Musick and Mrs. Warren were in charge of the 1950 Oxon Hill Elementary School safety patrol. Brooks Cross was the captain, and his lieutenants were Sally Gibson, Paul Stilson, and Fred Ritter. Carla Henry was a proud member of the safety patrol. (Courtesy of the Carla Henry Rosenthal collection.)

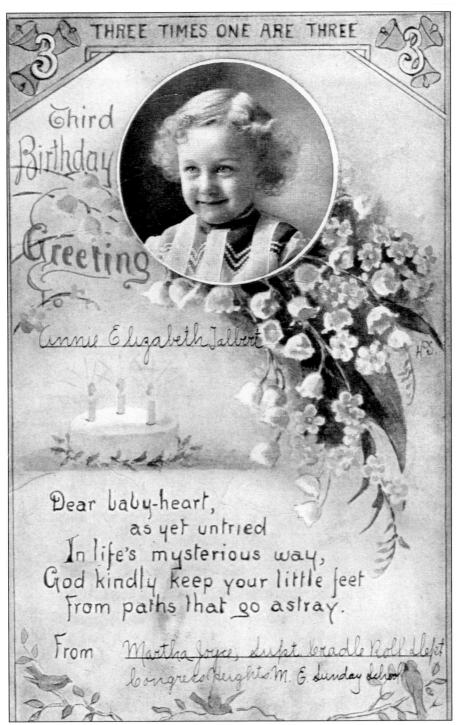

THREE TIMES ONE ARE THREE

Third Birthday Greeting

Annie Elizabeth Talbert

Dear baby-heart,
 as yet untried
In life's mysterious way,
God kindly keep your little feet
from paths that go astray.

From Martha Joyce, Supt. Cradle Roll Dept.
Congress Heights M. E. Sunday School

Martha Joyce, superintendent of the Cradle Roll depot at the Congress Heights M. E. Sunday school, gave Anna Talbert her third-birthday greeting card. Annie Elizabeth Talbert, only daughter of Sallie Hill and George Herbert Talbert, grew up with her three brothers on the family dairy farm off what is now known as Indian Head Highway (Courtesy of the Anna Talbert Mistretta collection.)

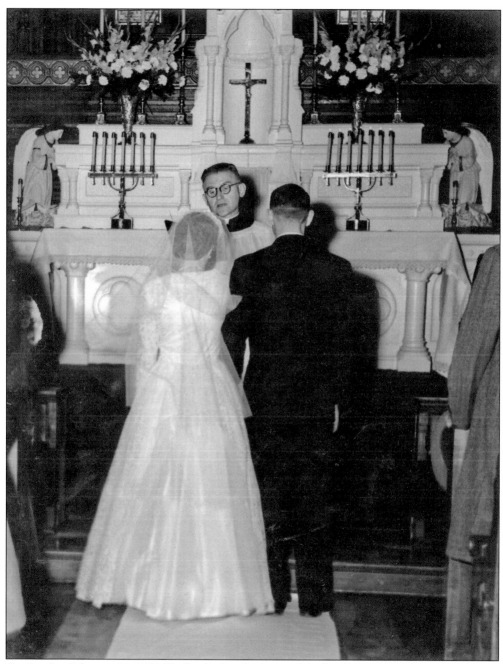

On Sunday, February 14, 1954, Phyllis Audrey Luskey and Arthur Dean Cox were married in St. Ignatius Catholic Church. Fr. Patrick J. Begley performed the ceremony. According to Mrs. Cox, the reason they married on a Sunday was that his employer would not let him off on Saturday. Therefore they planned their wedding on Valentine's Day, a Sunday. (Courtesy of the Phyllis and Arthur Cox collection.)

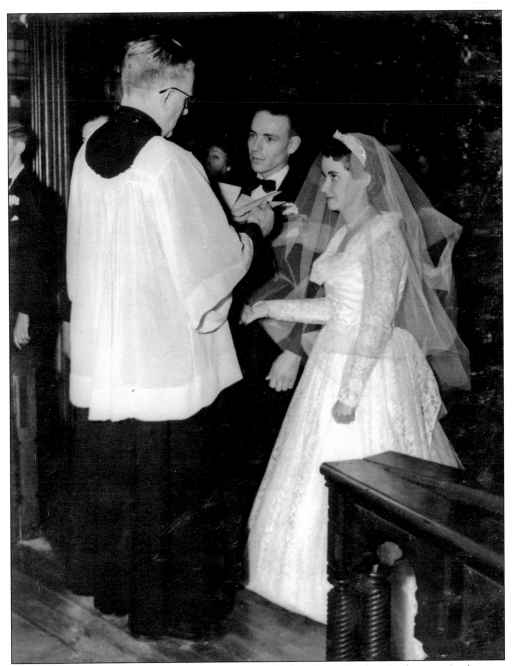

Phyllis A. Luskey and Arthur Cox stand at the altar before Father Begley. At the time, Luskey was not a Catholic; therefore, the service was performed not on the altar but below the altar in the old church. Luskey wore a beautiful satin-and-lace dress purchased at Garfinkle's, located at Fourteenth and F Streets, NW, in Washington, D.C. (Courtesy of the Phyllis and Arthur Cox collection.)

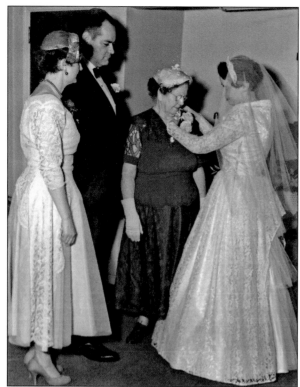

Prior to the Luskey-Cox wedding, the Luskeys, (from left to right) Agnes Bertha "Bertie" Maiden Cadell; Irving William Jr., Mary Agnes Cadell, and Phyllis Luskey, pose for an official portrait. A corsage is pinned on Mary Agnes Cadell (Mamie), Phyllis's grandmother. This picture depicts three generations of the Phyllis family. As a genealogist and preservationist, Phyllis continues to document both families and fights to preserve historic sites. (Courtesy of the Phyllis and Arthur Cox collection.)

Phyllis Luskey shows her garter to her sister, aunt, friend, and schoolmate. From left to right are Judith Lynn Luskey (sister), Phyllis Audrey Luskey (the bride), Virginia Luskey (aunt), and Paula Randall (schoolmate). (Courtesy of the Phyllis and Arthur Cox collection.)

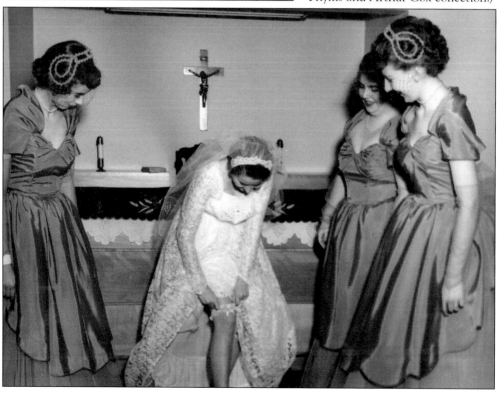

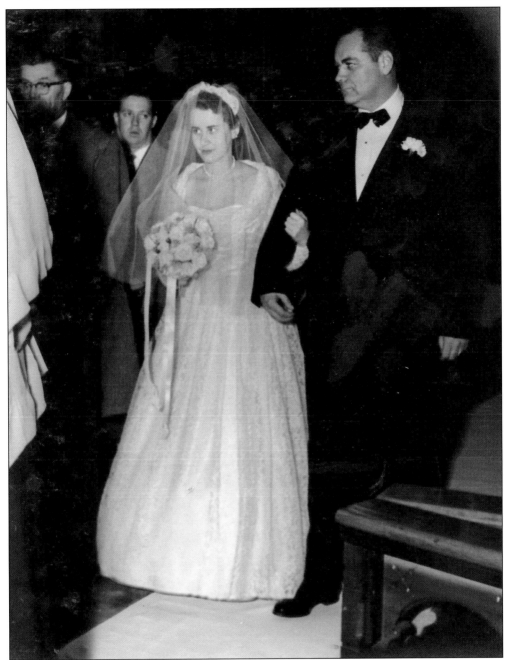

Irving William Luskey Jr. of Oxon Hill escorts his daughter Phyllis to meet her husband-to-be, Arthur Cox. The attendees included predominately family members of the Grimes, Hills, Talberts, and Luskeys. (Courtesy of the Phyllis and Arthur Cox collection.)

This is a 52-year-old invitation. The couple, the Coxes, preserved the invitation in their wedding album. Mrs. Cox said she and her family took care of most of the wedding planning. As the groom, Mr. Cox just showed up at the wedding. He was delighted to help as he could, though he worked most of the time. (Courtesy of the Phyllis and Arthur Cox collection.)

This is a photograph of Arthur Cox, son of Augustus Narvel "Gus" Cox. Augustus Cox was born August 7, 1896, in Oxon Hill. After he returned from the military, he married Mabel Estelle Hill. The couple had three children. On August 30, 1918, Cox enlisted in the military as a private at the age of 22. He served in this capacity until he was discharged on December 14, 1918. As a World War I soldier, Cox is buried in Arlington Cemetery. Arthur visits his father regularly. (Courtesy of the Phyllis and Arthur Cox collection.)

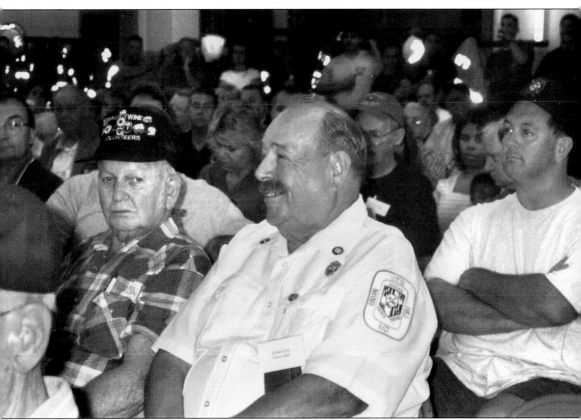

In June 30, 1949, Arthur Dean Cox joined the Oxon Hill Volunteer Fire Department. Cox served continuously with Oxon Hill, except during the time he was in the Korean War. He was Oxon Hill's driver, operating all of the equipment. Over 30 years, Cox responded to numerous calls. His highest yearly total was 769 calls. Cox serves on the Oxon Hill Fire Department Board of Directors. (Courtesy of the Phyllis and Arthur Cox collection.)

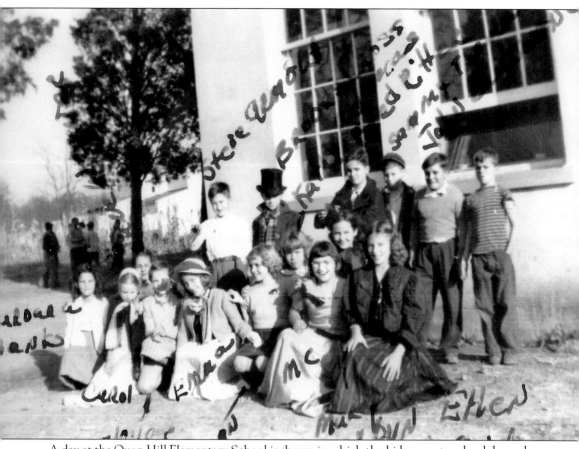

A day at the Oxon Hill Elementary School is shown in which the kids came to school dressed up in costumes. Carla Henry and her friends, Barbara Banks, Steven, Brooks, Carol, Joyce, Emma, Mary, Ellen, and other unidentified kids took time to take this photograph for posterity. (Courtesy of the Carla Henry Rosenthal collection.)

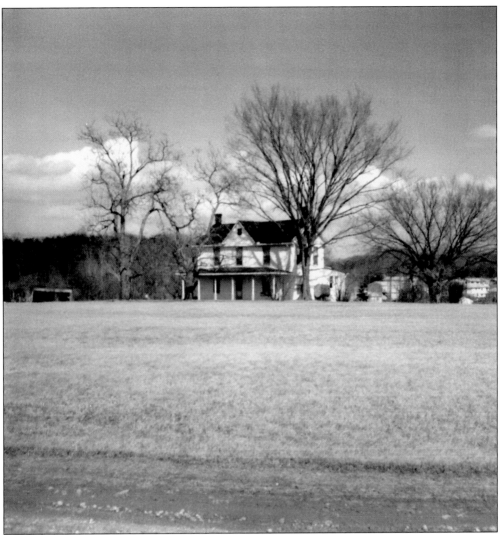

This photograph shows the birthplace of Augustus Nowal Cox, which is now Birchwood City Recreation Center. The house was located at 5608 Livingston Road in Oxon Hill. This is also the home of Charles William Cox, the grandfather of Arthur Dean Cox. On June 25, 1894, Rhoda Menetter "Nettie" Cox was the first child born in the house. (Courtesy of the Phyllis and Arthur Cox collection.)

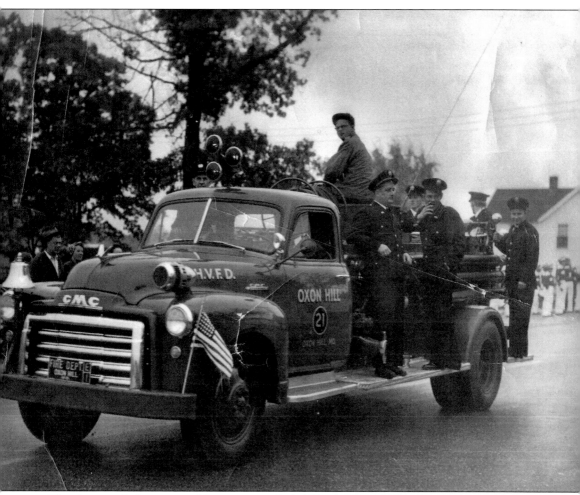

The photograph depicts one of the many parades held by the Oxon Hill Volunteer Fire Department. Standing on the left running board is Ed Jones. The man sitting on top is the photographer hired by the fire department. On the right running board are, from left to right, Leonard "Peg Leg" Adams, Henry Sheriff, and George Sheriff. The man on back with his head turned is Watson Taylor. The man on the back facing the front is Joseph Cox. (Courtesy of the Phyllis and Arthur Cox collection.)

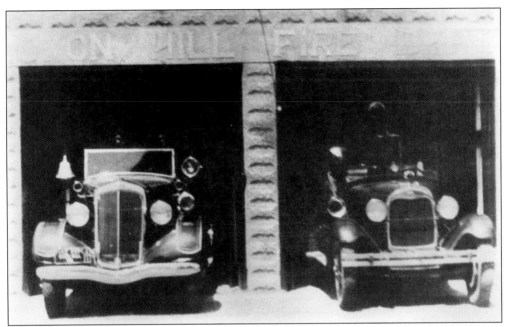

This photograph shows the original Oxon Hill Fire Department as it existed in 1935. The station housed Ford Model A fire trucks. Throughout the years, the Ladies Auxiliary assisted the firemen with raising funds for new equipment, uniforms, and other items needed to support the fire station. (Courtesy of the Phyllis and Arthur Cox collection.)

In 1962, Oxon Hill Substation 2142, located on Marcy Avenue in Forest Heights, was established to serve the community of Glassmanor. Glassmanor is an unincorporated community within the borders of the town of Forest Heights. It is located just off Livingston Road. The area has its own elementary school and is made up of mostly apartment units. At the time, the fire station had 50 volunteers. Of the 50, there are still 9 active volunteers. The volunteers fought fires in the area of the Southview Apartments. (Courtesy of the Phyllis and Arthur Cox collection.)

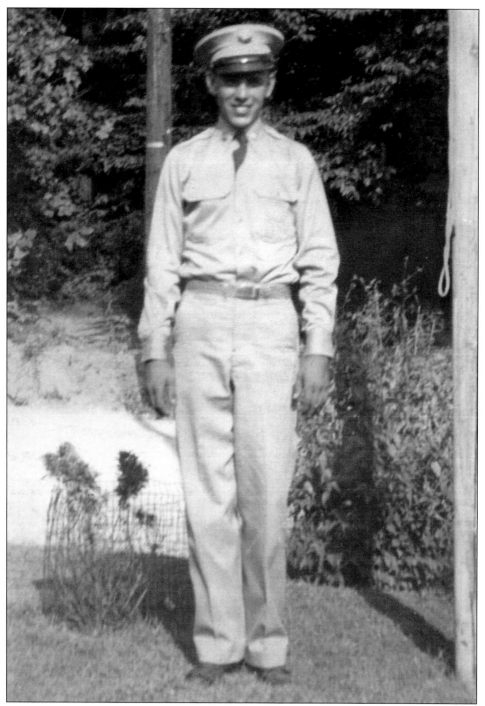

As a young man, Arthur Dean Cox enlisted in the U.S. Army. He spent eight months of basic training in Fort Lee, Virginia. While in the military, he transferred to Korea as a driver in the Quartermaster Company, 3rd Infantry Division. Cox spent 13 months as a member of the 3rd Infantry in Korea. While he was in Korea, the county dedicated the Oxon Hill Fire Department. (Courtesy of the Phyllis and Arthur Cox collection.)

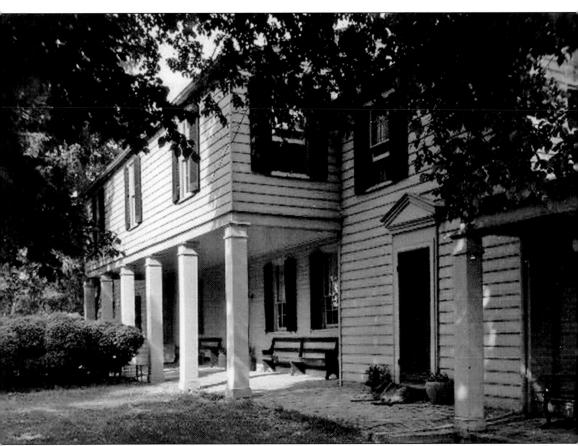

Salubria had a two-story portico added around 1900; grounds include early-19th-century outbuildings. It was home to five generations of the Bayne family. Dr. John H. Bayne, a prominent physician, agriculturist, and superintendent of county schools, lived in the home. Salubria has been home to the Addison, Breckenridge, and Castle families and was occupied by members of these families until 1989. Like many of his peers, Dr. Bayne held 19 slaves at Salubria. The home, which had been in disrepair, was bulldozed by the county. (Courtesy of the Maryland–National Capital Park and Planning Commission History Department.)

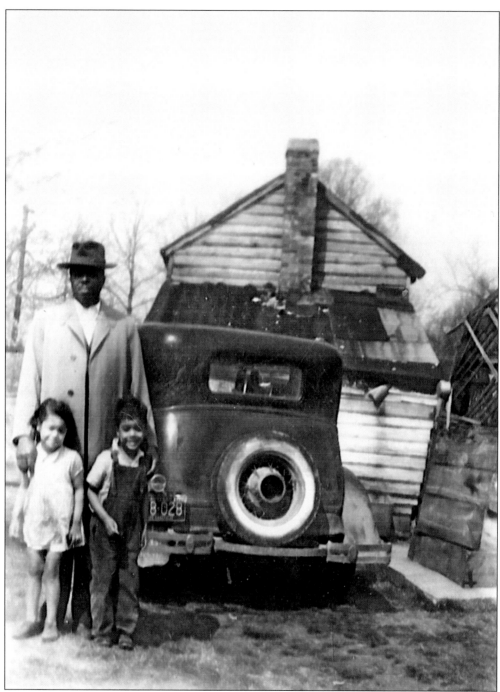

The unidentified individuals depicted in this photograph live near St. Paul United Methodist Church on St. Barnabas Road, one block from the church on a site called Proctorville. The residents of Proctorville originally came from rural areas in Charles and Anne Arundel Counties. They settled in this area, and some of them lived in the houses from 30 to 60 years. Current members of St. Paul still have relatives living in these old houses. (Courtesy of St. Paul's United Methodist Church.)

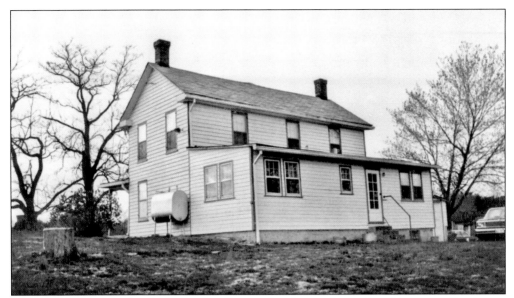

In 1889, Charles W. Cox built the Cox-Francis farmhouse, located on Livingston Road on a part of the Oxon Hill Manor estate owned by Thomas E. Berry. The house appears on the 1894 Hopkins Map of Washington, D.C., and vicinity. In 1901, Charles W. Cox died, but the house and property remained in the Cox family until 1931. In 1940, James M. Francis acquired the property after the settlement of the estate. The property remained in the Francis family. (Courtesy of the Maryland–National Capital Park and Planning Commission History Department.)

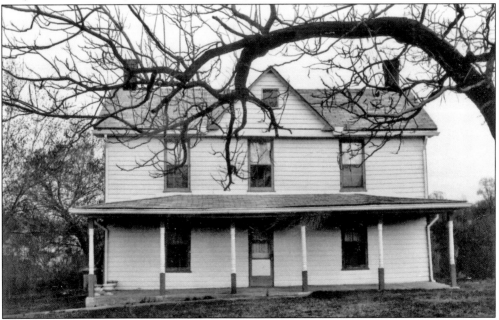

The Cox-Francis house is a rectangular two-story frame house typical of farmhouses built in the 19th century. The characteristics include the interior "I" plan, central cross gable on the entrance facade, and austerity in further architectural detail; the only stylistic accents on the house exterior are the turned porch posts. The house is occupied and has remained in private hands. (Courtesy of the Maryland–National Capital Park and Planning Commission History Department.)

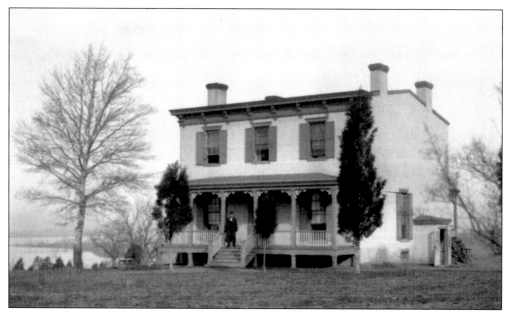

Mount Welby was the home of the Dr. Samuel DeButts family, who built the house in the 19th century. Mount Welby is a two-story brick house of Georgian plan with a shed roof and corbelled cornice; it was originally built with a gable roof. The house is prominently situated overlooking the Potomac River. The house and property were well maintained with more than 20 slaves in attendance. The house was named Welby in honor of John's wife, Mary Welby. (Courtesy of the Maryland–National Capital Park and Planning Commission History Department.)

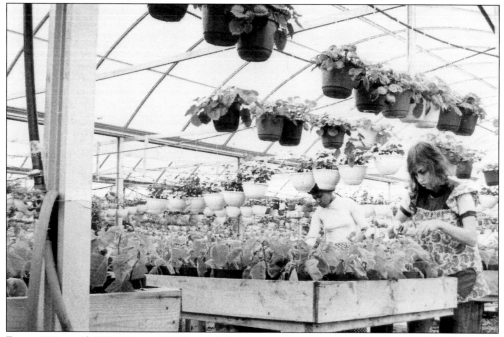

From 1891 until 1950, Mount Welby and the surrounding property were part of St. Elizabeth's farm, where it provided all of the fresh fruits, vegetables, and dairy products to the patients of St. Elizabeth's Hospital for the mentally ill. (Courtesy of the National Park Service.)

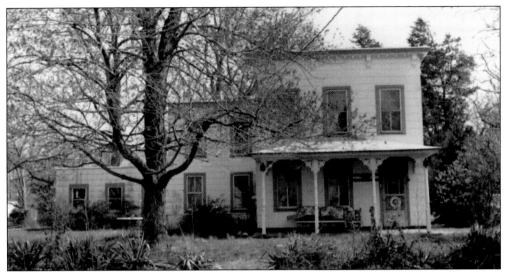

Souder House is a multi-section building plain in form but enriched with elements of fine Victorian-Italiante detail. It is a noticeable landmark in a residential community of modern, single-family homes. The Souder House was originally a part of Thomas Grimes's farms on the road from Grimes Crossroads in Washington, D.C. (Courtesy of the Maryland–National Capital Park and Planning Commission History Department.)

In 1883, John H. Brooke purchased 60 acres of land, built what is now known as the Souder House, and worked a farm across from St. Barnabas Church. In 1901, Brooke sold 15 acres and the house to Milo C. Burbage, a bricklayer/contractor from Ohio, and improved the outbuildings. By 1920, the main block had been expanded to its full size, the wing had been added, and the well enclosed in an additional one-story easterly section. In 1921, Joseph Souder purchased the 15-acre lot and replaced the tin roof and covered the siding with asbestos shingle. The property included two barns south and west of the house, which were destroyed. Since 1950, parts of the 15-acre lot have been subdivided among the Souder children, who have built brick residences on the property. The property has remained in the Souder family for more than 60 years. (Courtesy of the Maryland–National Capital Park and Planning Commission History Department.)

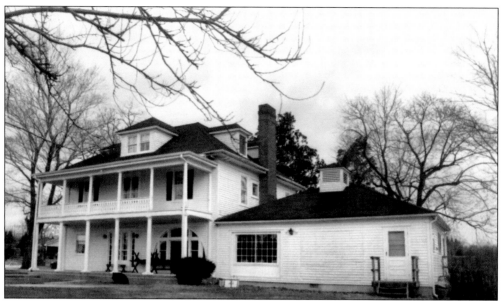

Terret House, located on Stonesboro Road, is a two-and-a-half-story hip-roof frame house of the Colonial Revival style. A wing was added to incorporate an original carriage house; the house is distinguished by the two-story verandas on two elevations and fine interior detail. There are two brick chimneys—one interior chimney rises from the south plane of the roof between the two dormers, and there is an exterior chimney at the north elevation. (Courtesy of the Maryland–National Capital Park and Planning Commission History Department.)

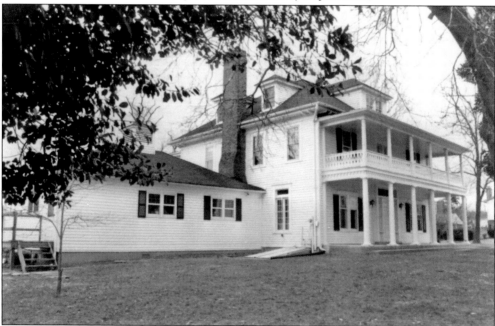

The Terrett House was built by the Terrett family in 1910 on the Bird Lawn Farm. The house was rebuilt in 1940 by Congressman Frederick Crawford of Michigan. The windows show beautiful workmanship. The house is privately owned. (Courtesy of the Maryland–National Capital Park and Planning Commission History Department.)

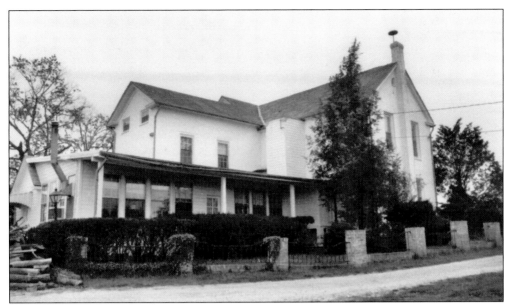

Kildare House is significant as a plantation house with a long history. The house is located high on a hill overlooking the Rosecroft Raceway to its south. It is a two-story brick gable-roofed dwelling with a T-shaped plan. The L-shaped main block has a two-story brick east wing completing the T shape. It is surrounded by rolling terrain that is fenced for horse pasture and is reached by a long, tree-lined gravel entry drive. The early structure has been altered so that its original orientation is not apparent. (Courtesy of the Maryland–National Capital Park and Planning Commission History Department.)

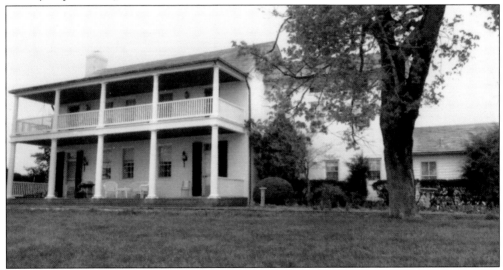

In 1854, Dr. Peter Heiskell purchased 320 acres of Tolson's Purchase from George S. Tolson. Dr. Heiskell died in 1893, but the property and house remained in the Heiskell family until 1945. William E. Miller of William E. Miller Furniture Company purchased the home and established the Rosecroft Raceway south of the property. The Kildare House remained in the Miller family until 1972, when Miller's widow died and the property passed to Riggs National Bank as part of a trust agreement. (Courtesy of the Maryland–National Capital Park and Planning Commission History Department.)

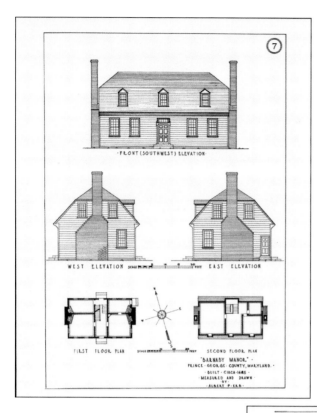

This image depicts the south front, west, and east sides and first- and second-floor plans of Barnaby Manor, located in Oxon Hill. The community is bounded on the north and east by Wheeler Road, on the south by Owens Road, and on the west by the Owens Road Neighborhood Park and Barnaby Village. Barnaby Manor was an early land patent located along Barnaby Run in the District of Columbia and Prince George's County. Many of the 20th-century subdivisions in the vicinity of this tract used the Barnaby name. (HABS, Courtesy of Library of Congress, Prints and Photographs Division.)

The image at right depicts Barnaby Manor's historic entrance door and the detail of the entrance door architrave. Most of the residential construction occurred in Barnaby Manor and adjacent Barnaby Village. The brick and frame ranch houses were constructed on large lots between one half and one acre in size. In the late 1950s and early 1960s, the two subdivisions were joined by the communities of Eastover Knolls, Martin Park, and Weaver's Knoll for an additional 145 houses. (HABS, Courtesy of Library of Congress, Prints and Photographs Division.)

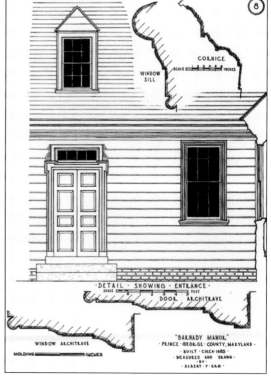

Hovermale's Tastes Best Ice Cream Stand is located at the intersection of Livingston Road and Indian Head Highway. Hovermale was built in the winter of 1953–1954 on a 17.88-acre parcel and is an excellent example of purpose-built, mid-20th-century roadside architecture. The ice cream stand opened for business on June 21, 1954, and since that time has been continuously operated by members of the Hovermale family. The building has been a recognizable and familiar landmark for more than 50 years. (Courtesy of the Maryland–National Capital Park and Planning Commission History Department.)

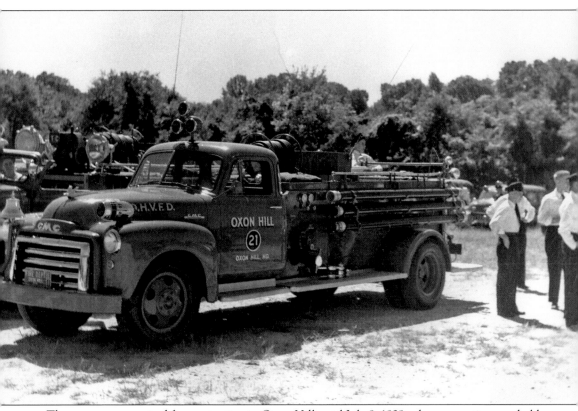

There was no organized fire protection in Oxon Hill until July 9, 1929, when a meeting was held at the Oxon Hill Elementary School to formally organize a volunteer fire department—Station 21. Today No. 21 is a fire and rescue squad located on Livingston Road; it is managed and operated by 4 full-time firemen and 19 volunteers who rotate 24-hour shifts. On January 7, 2004, units from the Oxon Hill station were the first to arrive at the fire on the historic Oxon Hill Manor. (Courtesy of the Miles collection.)

Seven

TOWN OF
FOREST HEIGHTS

Forest Heights began as a new subdivision in the Oxon Hill District in 1941. In 1949, Forest Heights, Maryland, was chartered, becoming the only municipality in southern Prince George's County. Forest Heights, originally a part of a 6,478-acre plantation, was established in 1687 by Col. John Addison and was called St. Elizabeth. In 1767, it was renamed Oxon Hill Manor. The original area of Forest Heights was 37 acres east of Indian Head Highway and 129 acres on the west side. In 1950, the total population was estimated at 1,125 people. Forest Heights has 3 churches, 3 elementary schools, 2 public parks, more than 900 single-family homes, and numerous apartment complexes.

On June 20, 1954, the town dedicated the Municipal Building on Arapahoe Drive, off Livingston Road. The Municipal Building serves multiple purposes, including hosting the monthly town meetings, a cooperative kindergarten, the police department, and the mayor's office. The building has always been used by many different groups for meetings, classes, and celebrations.

On April 19, 1999, this town celebrated its 50th anniversary as an incorporated municipality. In addition to the mayor, the town's government includes six council members who represent three wards for a two-year term. The first mayor was Maury Osborne, who served three terms. The longest mayoral term was held by Clifford Armhold, who was mayor for 22 years.

Forest Heights is known as a diversified community of many cultures who live in a harmonious environment. Forest Heights has always been a nice place to live, and it has been debt-free since its incorporation. From the beginning, it has represented the best of family, friend, and neighbor. Forest Heights is home.

The Forest Heights town sign located at the entrance to the Municipal Building announces the next town meeting. The town council meets on the third Wednesday of every month at 7 p.m. These meetings are open to the public, and all issues pertinent to the operation of the town are discussed there. (Courtesy of the Miles collection.)

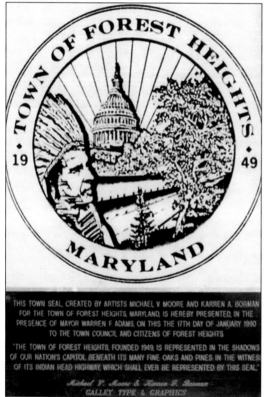

The official Forest Heights town sign leading to the parking lot of the Municipal Building is located on Arapahoe Drive. The bright orange sign shows the town's boundaries and includes a town map outlining all the streets, buildings of interest, and the election wards. Forest Heights is divided by Indian Head Highway. (Courtesy of the Miles collection.)

In the 1950s, Hot Shoppes, a famous chain of restaurants across the Washington metropolitan area, located a branch in the Glassmanor section of Oxon Hill. The Hot Shoppe, a community staple situated off what is now Indian Head Highway, was a favorite hangout for the young people of the community. Families could go there for an inexpensive meal. (Courtesy of the Carla Henry Rosenthal collection.)

The 1960s brought many large-scale apartment complexes, contributing to the town's rapid population growth. Glassmanor Community Center is located on Marcy Avenue in the middle of two- and three-family attached homes. It is conveniently behind the Glassmanor Elementary School at the end of a street with little traffic. The center offers the community many programs for children and adults, which include tumbling, dancing, knitting, and computer classes. Glassmanor is a community on the eastern side of Indian Head Highway and in very close proximity to the District of Columbia. (Courtesy of the Miles collection.)

Carla Henry played dress-up at school with friends. From left to right are Carla, Sammy, unidentified, Brooks Cross, Emma, unidentified, Flossy, unidentified, and other unidentified children having fun taking this photograph. (Courtesy of the Carla Henry Rosenthal collection.)

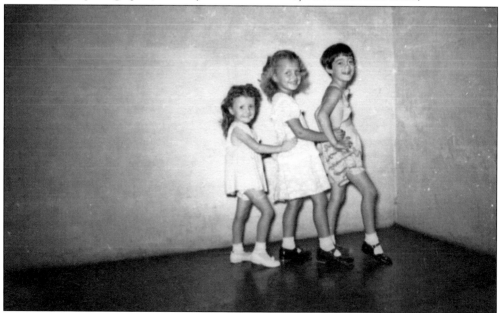

Dr. Charlotte Mistretta Bradley (center) is a researcher at the University of Michigan. She had high hopes of becoming a dancer but changed her dream while in college. At an earlier age, Charlotte appears in her tap-dancing class. The children performed at a slow pace while having fun. The dancers performed at churches and communities events. (Courtesy of the Anna Talbert Mistretta collection.)

Eight

COMMUNITY DEVELOPMENTS, PAST AND FUTURE

Oxon Hill, a stone's throw away from the Capital Beltway and convenient to the nation's capital, is a community bursting at the seams with a lot of residential growth and little commercial growth to meet the needs of its residents. It is a diverse urban community located minutes from the nation's capital and is considered a bedroom community that is host to a number of government agencies, such as the Internal Revenue Service, and several companies located in the Constellation Center. There have been several proposals and master plans to create and develop a downtown Oxon Hill, a waterfront community, and business district.

Constellation Centre is one of the first large-scale planned commercial developments in the Oxon Hill area designed to bring the community into the 21st century. Its original plan included three 10-story office buildings, a 150-room hotel, a free-standing restaurant, a bank building, and three-level parking garages. When completed, it would provide more than 600,000 square feet of office space. (Courtesy of the Thomas collection.)

The Lucente Complex encompasses 11 acres on Oxon Hill Road near Indian Head Highway and the Capital Beltway. It was one of the first commercial office buildings planned for the Oxon Hill area. In 1969, Lucente Enterprises completed two high-rise office buildings. The complex cost an estimated $45 million. (Courtesy of the Thomas collection.)

The Woodrow Wilson Improvement Project began in 2004, expanding the 6-lane bridge to a 12-lane bridge. The white blocks are the concrete foundations for the new bridge. The Woodrow Wilson Bridge is one of seven crossings over the Potomac River within the Washington metropolitan area. (Courtesy of http://www.roadstothefuture.com/Woodrow_Wilson_Bridge.html.)

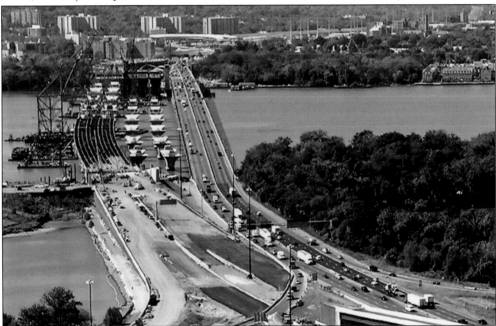

Woodrow Wilson Bridge is scheduled to be replaced by a new bridge in 2011. The existing bridge, shown to the right of the construction work, was named after Pres. Woodrow Wilson. It carries I-95 and I-495/Capital Beltway traffic from Oxon Hill, Maryland, to Alexandria, Virginia. The bridge has six lanes, is 5,900 feet long, and includes a draw span comprised of four bascule leaves that have a steel-grid deck roadway. The existing bridge carries over 200,000 vehicles per day and is quite congested. (Courtesy of http://www.roadstothefuture.com/Woodrow_Wilson_Bridge.html.)

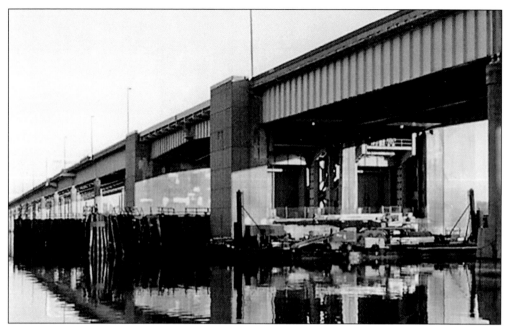

A photograph from the Maryland side of the bridge facing west into Alexandria provides a panoramic view of the white blocks inserted over steel and concrete beams, which were driven deep into the river to form the foundation for the new bridge. The new bridge will include 20 additional feet of main span clearance, which will reduce drawbridge openings by two-thirds. The estimated cost of the new bridge is $2.4 billion. (Courtesy of http://www.roadstothefuture.com/Woodrow_Wilson_Bridge.html.)

On December 28, 1961, 42 miles of the new Capital Beltway, including the Woodrow Wilson Memorial Bridge, opened in Maryland. All 64 miles were completed in August 1964, serving commuters traveling through the metropolitan area. To accommodate the heavy traffic, the beltway was widened to eight lanes by the Maryland Department of Transportation in 1972.

Nine

NATIONAL HARBOR PROJECT

In 1984, James T. Lewis Enterprises, Ltd., of Alexandria, Virginia, developed a master plan for a 463-acre, mixed-use port town strategically located near the Woodrow Wilson Bridge and minutes away from the nation's capital in Smoot Bay, Maryland. The port town design included office, retail, and residential spaces and a 22-story world trade center. This developer's dream was welcomed by county executive Parris Glendening and the Prince George's County Council because of its economic development in the Oxon Hill community. In the 1990s, the project was abandoned when the developer claimed bankruptcy.

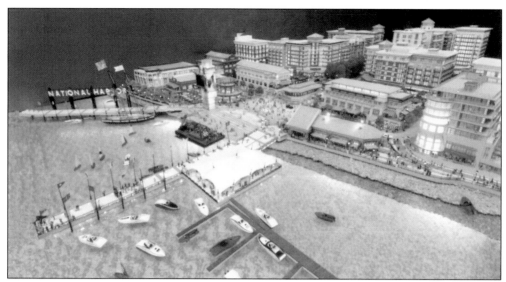

National Harbor, an extension of the Port America plan, is a high-intensity mixed-use waterfront property that creates a new identity and image of the Oxon Hill area. The community will include 2,500 residential units, 1 million square feet of retail, dining, and entertainment space, 4,000 hotel rooms, a convention center, and 500,000 square feet of class-A office space. National Harbor is an approved development project for a major mixed-use commercial and entertainment venue of metropolitan significance. (Courtesy of http://www.nationalharbor.com.)

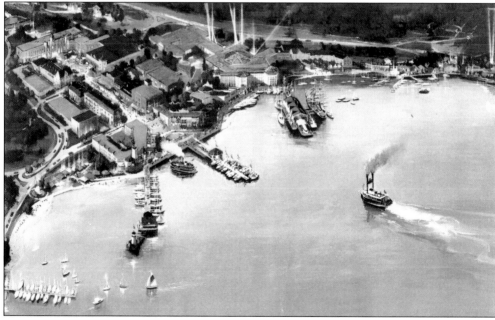

This scale model shows a completed view of National Harbor, which includes the convention center, visitor's center, hotel, office complex, private slips, and residential waterfront properties, as well as associated vehicular transportation, parking facilities, pedestrian walkways, and other infrastructure improvements. The proposed resort is to be built on 533.9 acres in Prince George's County south of the Capital Beltway. (Courtesy of the Prince George's County Executive's Office, Video and Photography Department.)